Introduction to Photography

Mark Galer

A Visual Guide to the Essential Skills of Photography and Lightroom

Introduction to Photography

A Visual Guide to Mastering
Digital Photography and Lightroom

Mark Galer

Focal Press
Taylor & Francis Group

NEW YORK AND LONDON

First published 2015
by Focal Press
70 Blanchard Road, Suite 402, Burlington, MA 01803
and by Focal Press
2 Park Square, Milton Park, Abingdon, Oxon OX14 4RN

Focal Press is an imprint of the Taylor & Francis Group, an informa business

Notices
Knowledge and best practice in this field are constantly changing. As new research and experience broaden our understanding, changes in research methods, professional practices, or medical treatment may become necessary.

Practitioners and researchers must always rely on their own experience and knowledge in evaluating and using any information, methods, compounds, or experiments described herein. In using such information or methods they should be mindful of their own safety and the safety of others, including parties for whom they have a professional responsibility.

Product or corporate names may be trademarks or registered trademarks, and are used only for identification and explanation without intent to infringe.

This book has been prepared from camera-ready copy provided by the author

Library of Congress Cataloging in Publication Data
Galer, Mark.
Introduction to photography : a visual guide to mastering digital photography and Lightroom / Mark Galer.
pages cm
1. Photography. 2. Photography--Digital techniques. 3. Adobe Photoshop lightroom. I. Title.
TR146.G1366 2015
770--dc23
2015000839

ISBN: 978-1-138-85450-5 (hbk)
ISBN: 978-1-138-85451-2 (pbk)
ISBN: 978-1-315-72106-4 (ebk)

Typeset in Helvetica Neue
By Mark Galer

Printed and bound in India by Replika Press Pvt. Ltd.

Acknowledgements

To my wife Dorothy, my children Matthew and Teagan and my father David.

Thank you for your love and support.

I would also like to thank Sony Alpha Australia and Adobe for their ongoing support for me as an educator and Kimberly Duncan-Mooney and Anna Valutkevich at Taylor and Francis for their support for this project.

Picture Credits

Cambridgeincolour, Sony; iStock Photo (page 20).

All other images that appear in this book are by the author.

To all the people who either posed for me and allowed themselves to be photographed or who were captured by my roving photographic eye I am eternally grateful.

MARK GALER has a commercial background in editorial photography and is a recognized Photoshop expert. He has been a Senior Lecturer in Photography at RMIT University and has published twenty-one photography titles for the international publisher Focal Press.

His books have been translated into seven languages including Chinese and Russian and have been adopted widely across Europe and the USA as curriculum texts for aspiring commercial photographers.

Mark Galer
Sony Ambassador

The aim of this short course is to provide you with the essential skills to capture creative photographic images.

You will learn how to take your camera out of Auto or Program mode and adjust aperture, shutter speed and ISO settings. This will enable you to creatively change the visual outcome to suit the subject you are photographing.

As with all craft skills, it requires repeated practice before these skills will become 'second-nature' so that you can then focus on your subject instead of your camera.

Contents

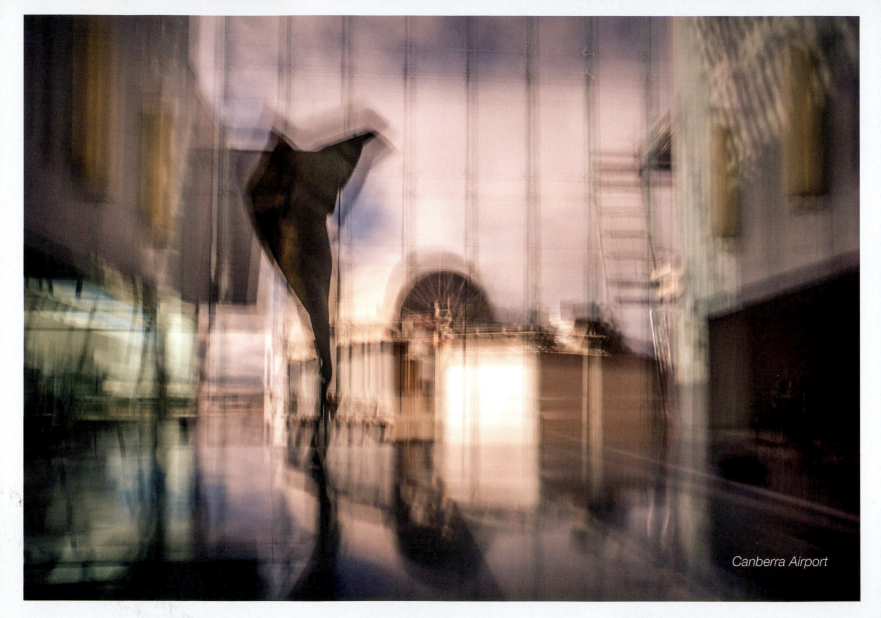

Canberra Airport

Course Overview

Study this Technical module until you are comfortable with the camera settings and concepts being outlined.

Read the FOUR creative challenges in the 'Creative Challenge' module and then capture images that meet the technical criteria of each challenge. The images that you capture will teach you how you can work with your camera optimized for four shooting scenarios.

Optimize the images using Lightroom (as guided by the 'Image Editing' module of this guide) and then submit four 'Raw' images from each challenge that demonstrate your understanding and skills.

For more information, videos, and tutorials, please visit i2p.markgaler.com.

Equipment and Materials

Camera: To complete this course you need a DSLR or interchangeable lens camera (ILC) or a 'prosumer' fixed lens camera that can shoot in the Raw (unprocessed) file format.

Lens: The camera's lens must be able to zoom from wide angle to short telephoto. A standard kit zoom on will suffice or any fixed lens prosumer camera with a 3x zoom or greater.

Software: Use the current version of Photoshop Lightroom and keep the software up-to-date.

Course Information

If you are using this text as part of a college course follow these guidelines so that your teacher can assess your work for the creative challenges.

- Use available light only. Do not use flash photography for this course.
- Set the current time and date in the camera's menu.
- Do not photograph at night (twilight is OK).
- Seek permission when photographing on private property.
- Do not use lens-adapters to attach non-standard lenses.
- Only photograph strangers in a public place, and be considerate to people's wishes if they do not want to be photographed.

Technical Section

Eureka

Exposure

Metering Modes

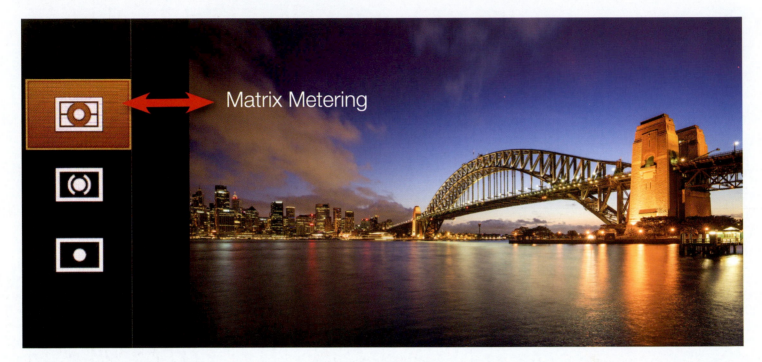

Matrix Metering

Cameras measure subject brightness and then 'Expose' the 'image sensor' to the light. Varying the 'Exposure' will control how light or dark your image appears. Different 'Metering Modes' enable the camera to measure subject brightness either in the center of the frame (spot or center metering) or across the entire frame (Matrix or Evaluative metering). Matrix or Evaluative metering is recommended for general use.

Exposure Modes

The Exposure or 'Shooting Modes' ALL ensure the right amount of light reaches the camera sensor. There are three ways to control how the correct amount of light reaches the image sensor. Aperture, Shutter Speed and ISO all have a bearing on how much light is collected. Varying these three settings changes the visual appearance of the image in subtle or dramatic ways.

Aperture

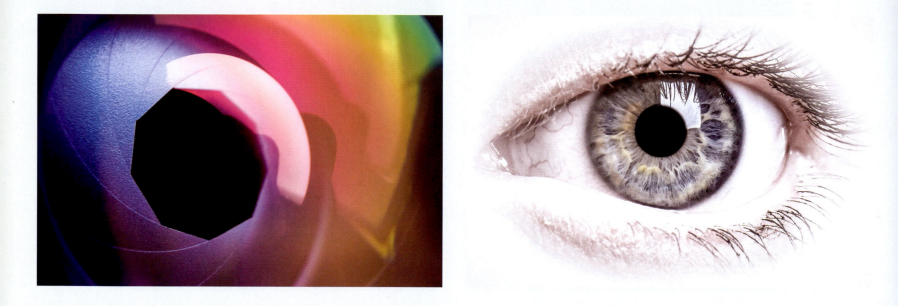

The aperture in the lens controls the intensity of light reaching the camera sensor just as the pupil in the human eye can adjust its size to allow more or less light to reach the retina.

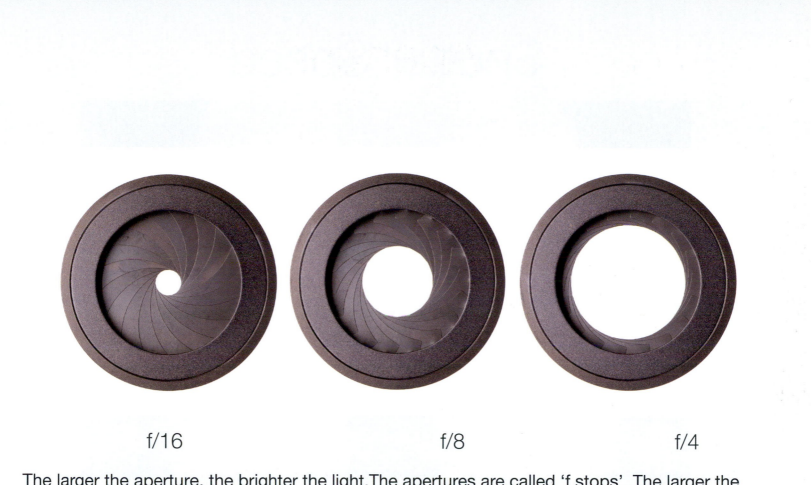

f/16 f/8 f/4

The larger the aperture, the brighter the light. The apertures are called 'f stops'. The larger the 'f-number', the smaller the aperture.

Shutter Speed

The shutter speed controls how long the sensor is exposed to the light. Cameras use a mechanical curtain that opens and closes. The longer the curtain stays open, the greater the amount of light that reaches the sensor.

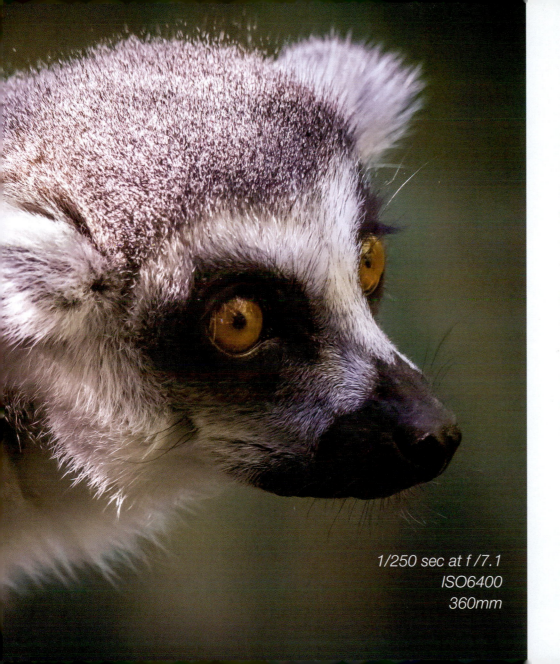

1/250 sec at f /7.1
ISO6400
360mm

ISO

Raising the camera's ISO setting increases its sensitivity to light, i.e. the sensor requires less light to achieve the same exposure. Raising the ISO will, however, lower image quality. The latest sensors are capable of being pushed to high ISO settings, with only a small loss in quality. This loss in quality is apparent through raised 'noise' and loss of fine detail. To ensure maximum quality keep the ISO as low as possible.

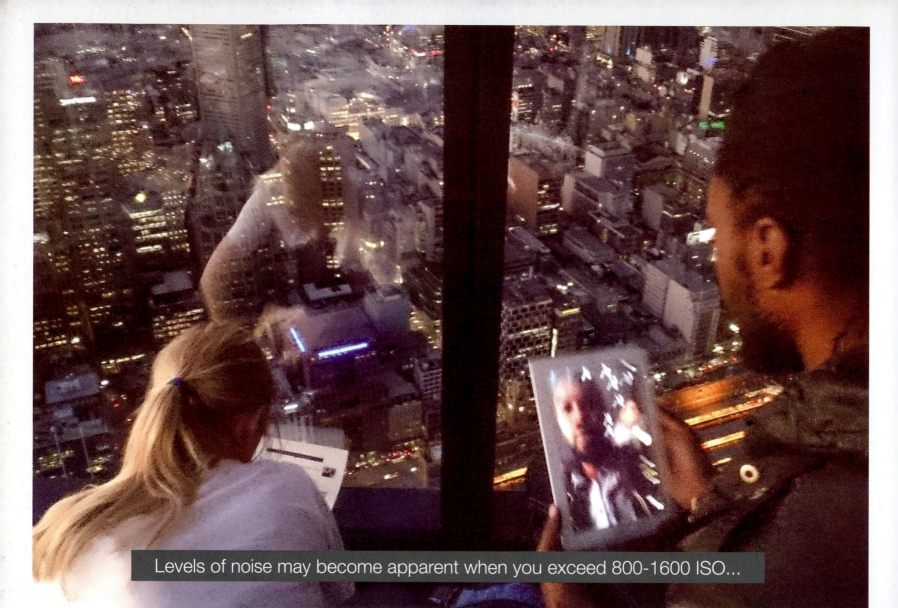

Levels of noise may become apparent when you exceed 800-1600 ISO...

...but when needs arise, some cameras can use ISO values of 12,800 and higher and still retain reasonable quality.

Depth of Field

Depth of field is the amount of the image from foreground to background that is in focus. Depth of field is controlled by:

Aperture
Sensor Size &
Distance to Subject (Focus Distance)

Note > Telephoto lenses appear to create images with shallower depth of field. If, however, the subject is the same size in the frame when using a telephoto and a wide angle lens, the total depth of field is constant – even though the focal length may change. You would need to move closer or move further away when using different focal lengths to keep the subject the same size.

Aperture

Choosing a different aperture has an impact on how much of your subject will be rendered sharp (depth of field)

1/100 sec at f/5,
ISO800
180mm

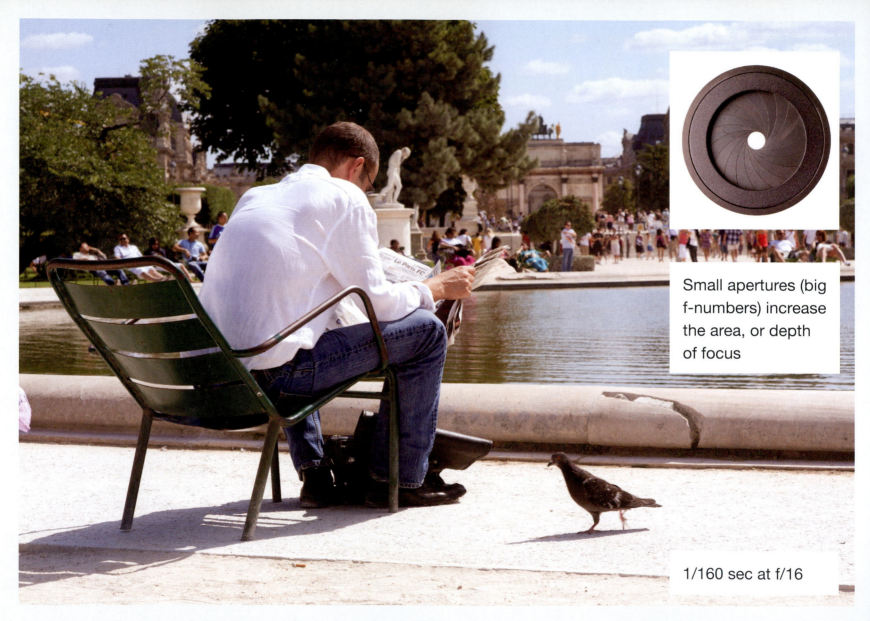

Small apertures (big f-numbers) increase the area, or depth of focus

1/160 sec at f/16

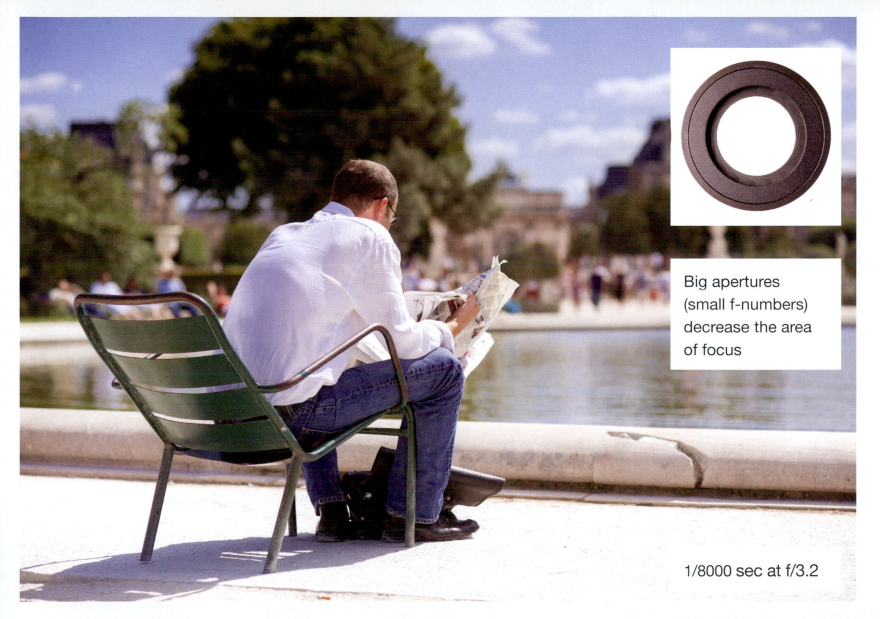

Big apertures
(small f-numbers)
decrease the area
of focus

1/8000 sec at f/3.2

Sensor Size

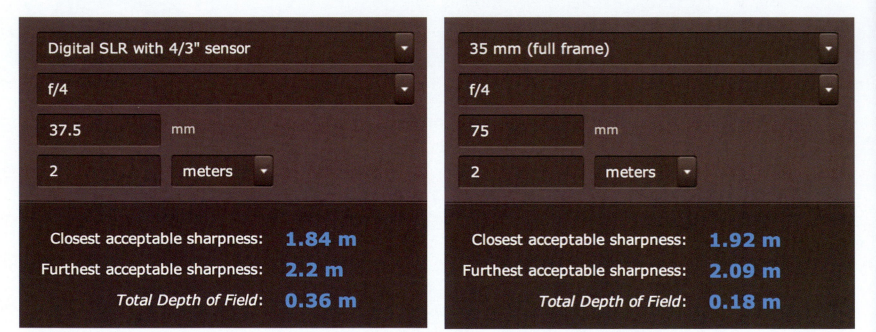

Digital SLR with 4/3" sensor			35 mm (full frame)		
f/4			f/4		
37.5	mm		75	mm	
2	meters		2	meters	
Closest acceptable sharpness:	**1.84 m**		Closest acceptable sharpness:	**1.92 m**	
Furthest acceptable sharpness:	**2.2 m**		Furthest acceptable sharpness:	**2.09 m**	
Total Depth of Field:	**0.36 m**		*Total Depth of Field*:	**0.18 m**	

http://www.cambridgeincolour.com/tutorials/dof-calculator.htm

Depth of field decreases as sensor size increases. Cameras using cropped sensors (APS-C, 4/3 inch or 1 inch) will require a wider aperture to achieve the same shallow depth of field as a camera with a full-frame sensor. Find out the sensor size of your camera as the 'Creative Challenges' in this course will refer to focal lengths of the lens as being 'full-frame equivalent'. (http://cameraimagesensor.com).

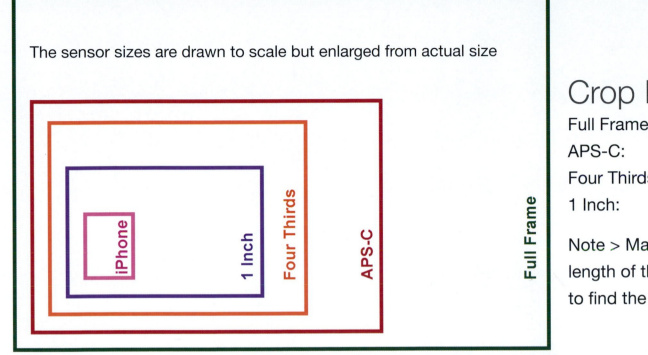

The sensor sizes are drawn to scale but enlarged from actual size

iPhone | 1 Inch | Four Thirds | APS-C | Full Frame

Crop Factor

Full Frame: x 1

APS-C: x 1.5 or 1.6 (Canon)

Four Thirds: x 2

1 Inch: x 2.7

Note > Magnify the actual focal length of the lens by the crop factor to find the full-frame equivalent.

Full-Frame Equivalent

For APS-C sensors you may need to multiply the focal length of your lens by 1.5 (Nikon) or 1.6 (Canon) to discover the 'full-frame equivalent'. For 4/3 inch sensors (Olympus and Lumix) you may need to double the focal length and apply a 2.7 times magnification when using a 1 inch sensor. Some cameras may, however, show the equivalent focal length rather than the actual focal length on the lens or in the viewfinder/LCD. If in doubt, ask a camera dealer or Google the answer.

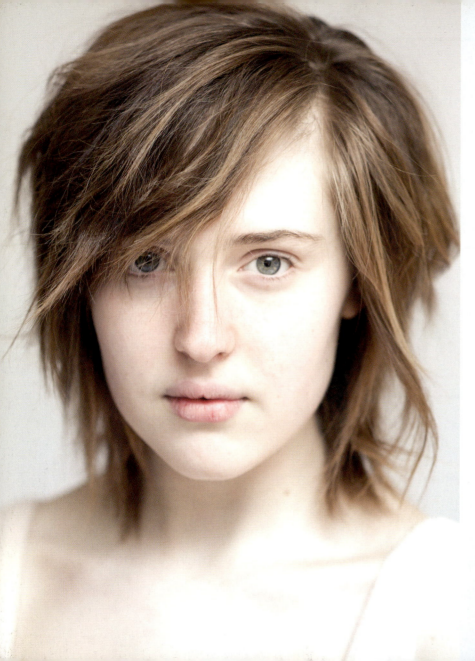

Distance

Depth of field decreases as the distance to your subject decreases.

If you want shallow depth of field - move closer.

1/200 sec at f/2.8
ISO200
85mm

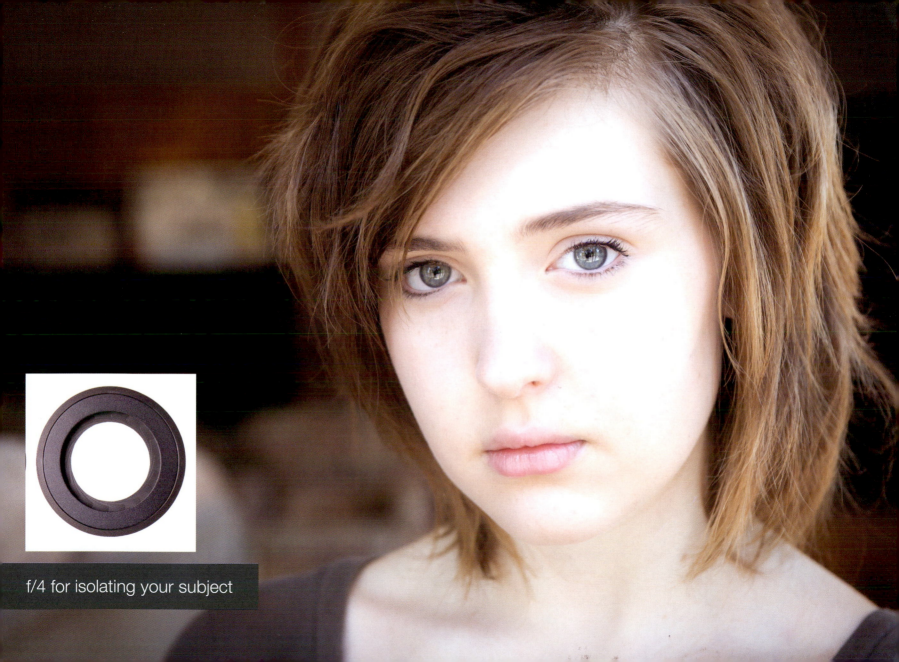

f/4 for isolating your subject

f/11 or f/16 for depth and drama

Choosing a small aperture to extend the depth of field will require a slower shutter speed to compensate for the lower light intensity.

1/40 sec at f /16
ISO200
24mm

Essential Camera Settings

Drive Modes

The 'Drive Mode' on an interchangeable lens camera allows the user to switch between 'Single Shooting' and 'Continuous Shooting'. In 'Single Shooting' mode, one image is captured each time the shutter release is pressed, while in 'Continuous shooting' the camera continues to capture images as long as the shutter release is held down.

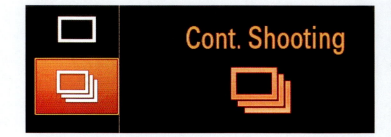

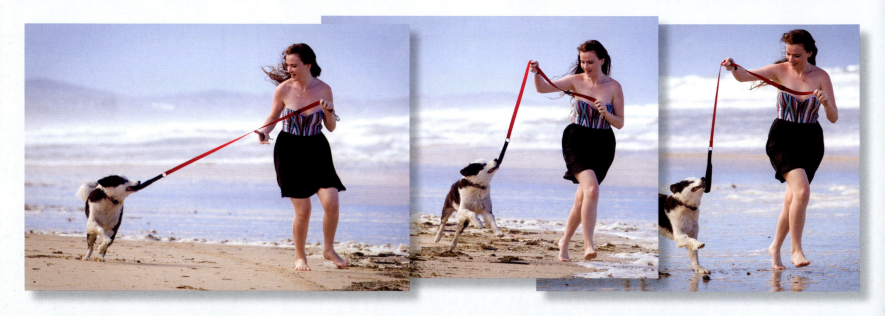

Yellow-faced Honeyeater

Focus Settings

To gain precise focus a photographer can choose to use Auto Focus (AF) or Manual Focus (MF).

When the camera is set to Auto Focus, and the photographer half-presses the shutter release button, the camera will focus automatically. The photographer must then wait for a moment while the camera focuses before fully depressing the shutter release to capture the image.

The camera's Auto Focus settings can be changed depending on the following:

- Whether the subject is stationary or moving
- The position of the subject in the frame.

Changing the 'Focus Mode' and 'Focus Area' settings will then optimize your camera's Auto Focus settings for the subject you are photographing.

Focus Mode (AF Mode)

The optimum Auto Focus setting for Stationary Subjects is:

'**Single-shot AF**' or '**AF-S**' (Sony, Nikon, Olympus etc.) or '**One-Shot AF**' (Canon)

Focus Mode (AF Mode)

The optimum Auto Focus setting for a Moving Subject is:

'**Continuous AF**' or '**AF-C**' (Sony, Nikon etc.)
'**AI Servo**' (Canon)

Note > Some cameras have an additional 'hybrid' option that allows the camera to switch between AF-S / Single Shot and AF-C / AI Servo when it detects a stationary subject is moving or vice versa. Some cameras may also have additional options for locking onto, and then tracking, a moving subject, e.g. Lock-on AF (Sony), Dynamic 3D Focus (Nikon) or Face Detection AF.

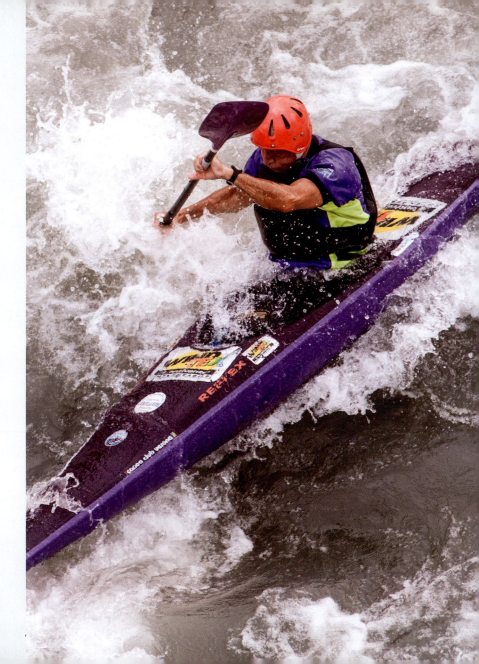

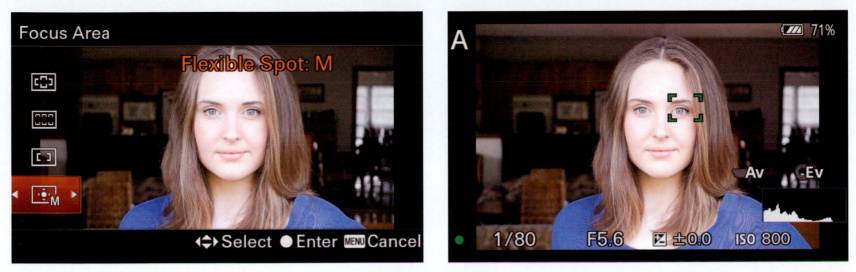

The Focus Area on this Sony camera has been changed to Flexible Spot and moved over the model's eye

Focus Area

There are three main focus area choices found on most cameras:

1. Wide or Auto Selection (the camera will decide, or guess, where and what to focus on).

2. Flexible Spot (Sony) or Single Point (Canon and Nikon). This is the most accurate way of focusing on your subject when the subject is stationary in the frame.

3. Zone (the photographer chooses an approximate area in the frame or increases the number of focus points, e.g. D9 on a Nikon). This is great for subjects that are moving around the frame).

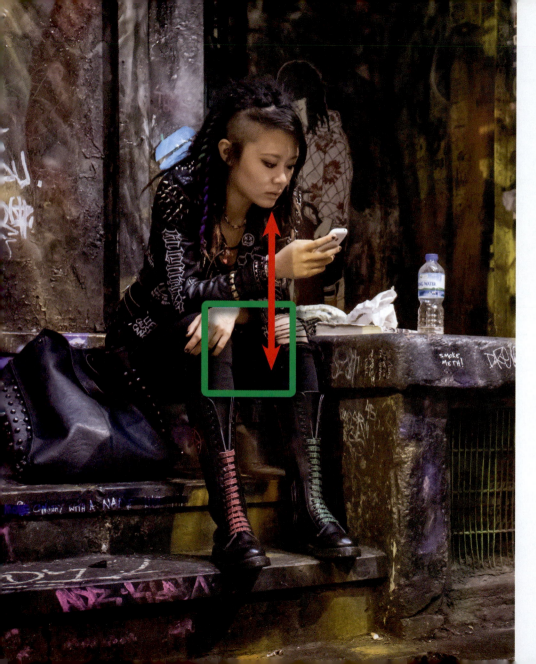

Focus Technique One

1. Choose AF-S / One-Shot AF.
2. Choose a 'Single Point' or 'Flexible Spot' as the Focus Area.
3. Set the 'Drive Mode' to 'Single Shooting'.
4. Leave the focus point in the center of your frame and then move the camera in order to position the focus point over your subject.
5. Half-press the shutter release to focus.
6. Re-frame your subject and then fully depress to capture the image.

Note > The shape and color of the focus point will vary between different cameras.

Focus Technique Two

1. Choose AF-S or One-Shot AF as the Focus Mode.
2. Choose a Single Point or Flexible Spot as the Focus Area.
3. Set the Drive Mode to Single Shooting.
4. Frame your subject.
5. Move the Single Point / Flexible Spot focus point until it is positioned over your subject (you will need to find out which camera control or button you need to press to enable the focus point to move).
6. Half-press the shutter release to focus, and when the camera indicates focus has been achieved, fully depress the shutter to capture your image (without re-framing).

Note > The shape and color of the focus point will vary between different cameras.

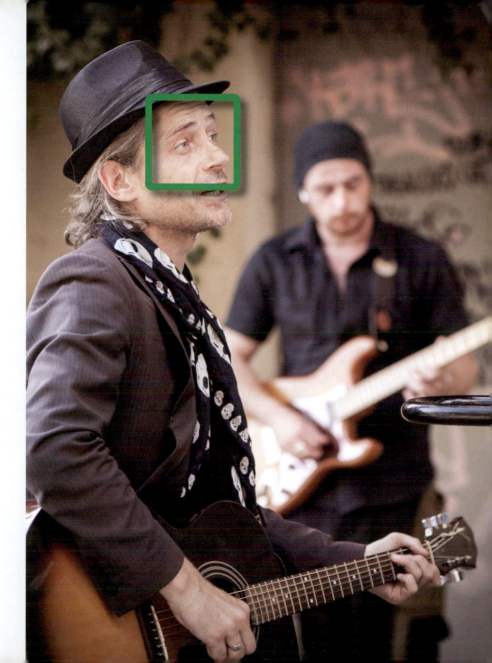

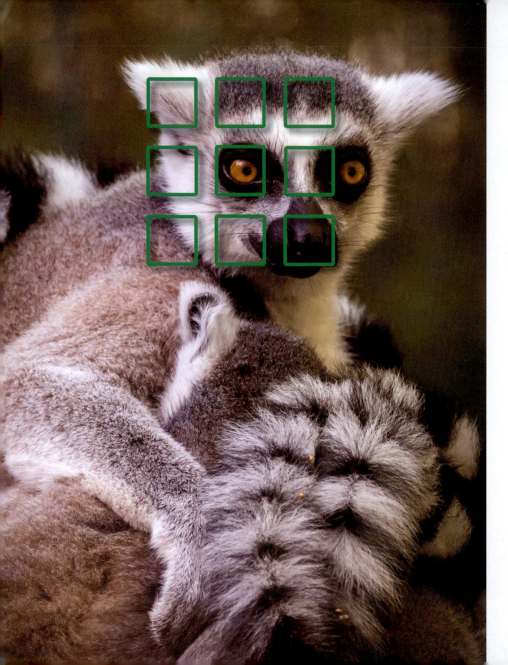

Focus Technique Three

1. Choose AF-C or AI Servo as the Focus Mode.
2. Choose 'Zone' as the Focus Area.
3. Set the 'Drive Mode' to 'Continuous Shooting'.
4. Position the zone of focus in an area of the frame where your subject will appear.
5. Half-press the shutter release when the subject appears in your zone of focus.
6. Fully depress the shutter release and let the camera take multiple images while trying to keep the zone over the moving subject

Note > The pattern and color of the zone focusing will vary between different cameras.

Sunflower - captured with Focus Technique One

Image Quality

A JPEG is a compressed image file. The higher the compression, the lower the quality. A Raw image file provides the photographer with the uncompressed data from the image sensor. Choosing Raw stops the camera from processing the file, i.e. the camera will be prevented from modifying the contrast, sharpness, saturation or white balance. Choosing Raw as your Quality setting will prevent you from selecting many options in the camera menu (such as the picture styles or picture controls) but will give you access to the highest quality data to process your image in software such as Photoshop. Keep your imaging software up-to-date to ensure you can open the Raw files from your camera.

For the Creative Challenges in this course choose Raw from the Quality settings in your camera's menu. Raw files are not compressed so their file size is larger when compared to JPEG files – so expect your memory card to fill more quickly.

White Balance

The color of light changes during the course of the day and changes depending on the source of the light, e.g. sunlight, electric light globes, candles, fluorescent tubes etc. During the day, the light may appear warm or cool. The color of this light can be measured in degrees kelvin and is referred to as the color temperature. Just as our eyes adapt to different levels of brightness, they also adapt to the differences in color temperature so that neutral tones (such as white or gray clothes or paper) always appear neutral after a while. Cameras can also adapt to these changes in color temperature by adjusting the White Balance. This can be done manually via the White Balance settings or automatically by setting the White Balance to 'Auto'. When shooting Raw the white balance can be changed in post-production.

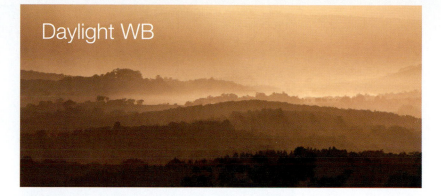

Daylight WB

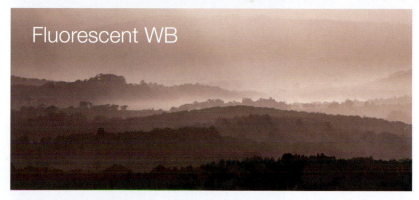

Fluorescent WB

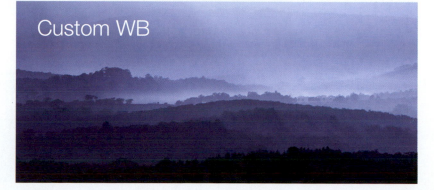

Custom WB

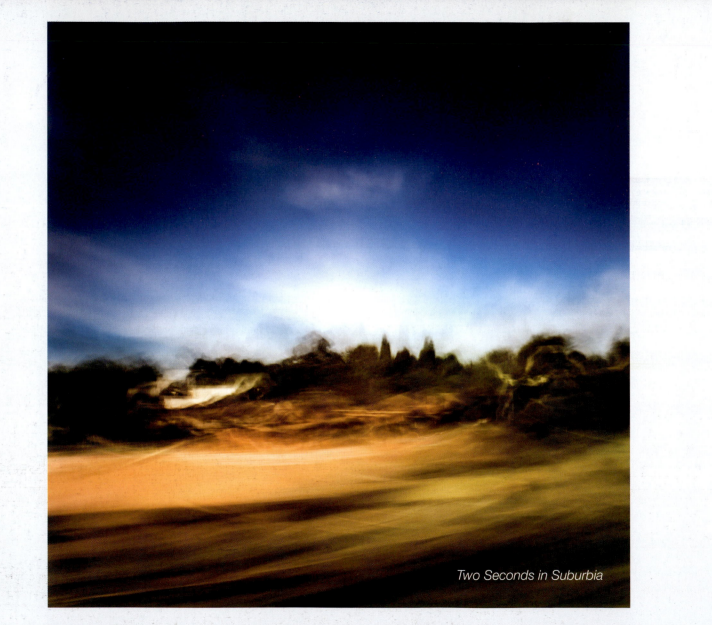

Two Seconds in Suburbia

Camera Shake and Movement Blur

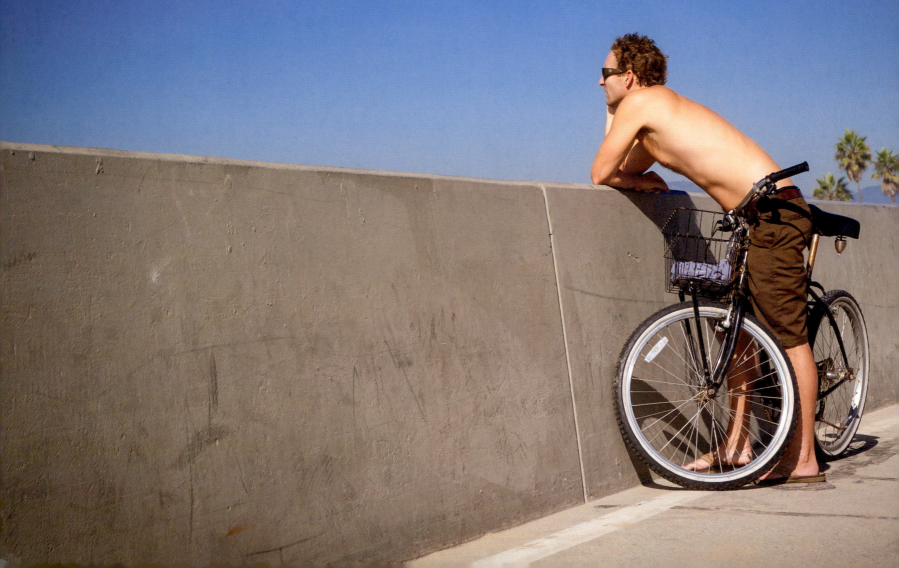

1/50 second is usually fast enough to avoid camera shake when using a standard zoom or 50mm

1/50 second will not, however, freeze a moving subject.

Note > If you want to reverse the blur (bike sharp and building blurred) just 'pan' or move the camera to follow the bike.

1/80 sec at f /11
ISO400
24mm

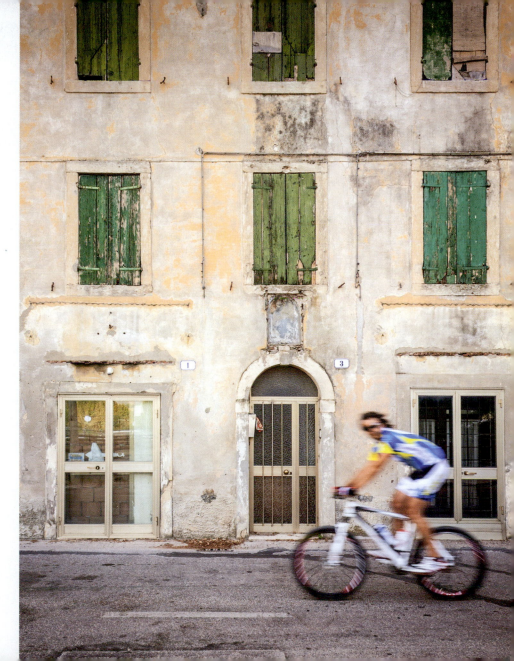

1/200 sec at f /4
ISO6400
170mm

Choosing a fast shutter speed to freeze the action may need a wider aperture to compensate for the reduced exposure.

1/8 sec at f /16
ISO100
15mm

When the light is dim and the subject is still, the photographer can achieve maximum depth of field by mounting the camera on a tripod to avoid camera shake.

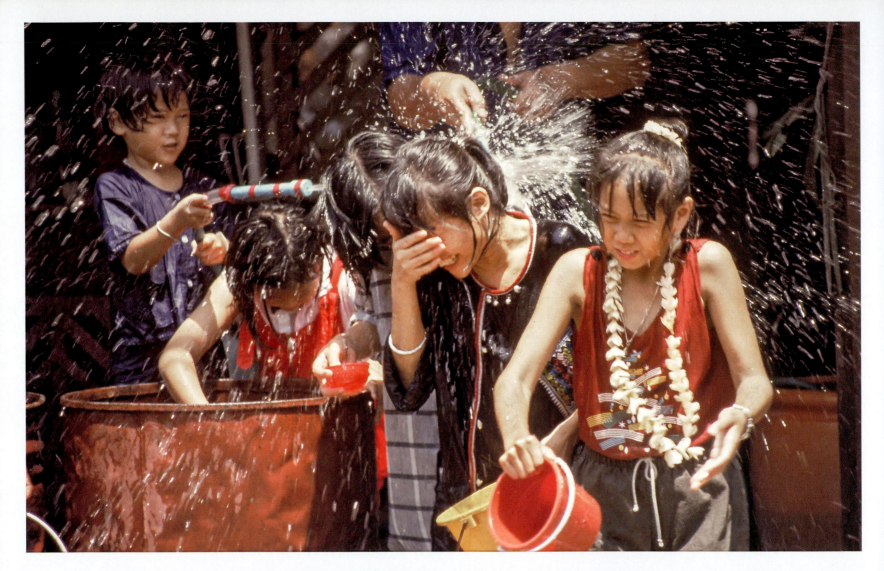

Choose faster shutter speeds to freeze faster action.

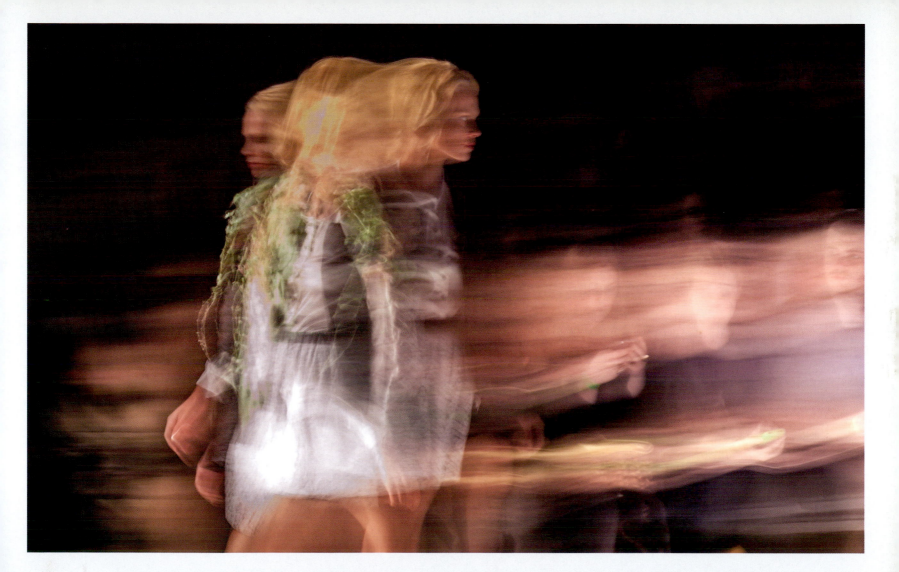

Choose longer shutter speeds and move the camera (pan) to follow your subject.

Exposure Compensation

Average Exposure

Rain or shine, your camera does not know what the weather is. If it did, it would be more reliable at setting the correct exposure. On a sunny day, when the shadows are clearly defined, a correct exposure would be f/16, 1/125 second and ISO 125. This is called the 'Sunny 16' rule. The camera's exposure meter, however, seeks to guide the camera to set an exposure that renders the tones framed to an average value. Some scenes are, however, far from average. When we encounter these scenes we need to adjust the exposure brighter or darker.

The 'Sunny 16' Rule*

*Although I like to increase the exposure slightly when using the Raw file format.

The Auto exposure modes (PASM) are not guided by the 'Sunny 16' rule, however, but by the rule of averages. In scenes that do not conform to 'the average' there is a risk of under or overexposure...

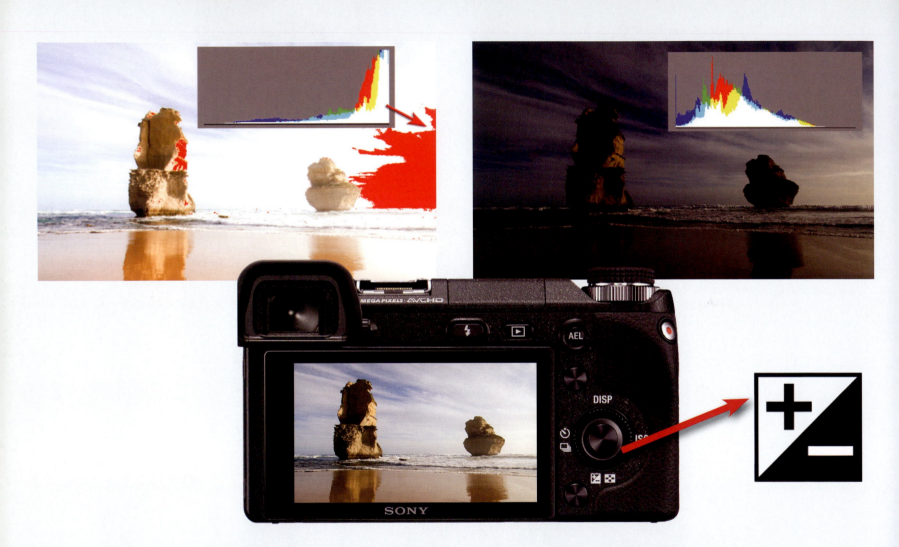

...and this is why we need to use 'exposure compensation'

Overexposure Warnings

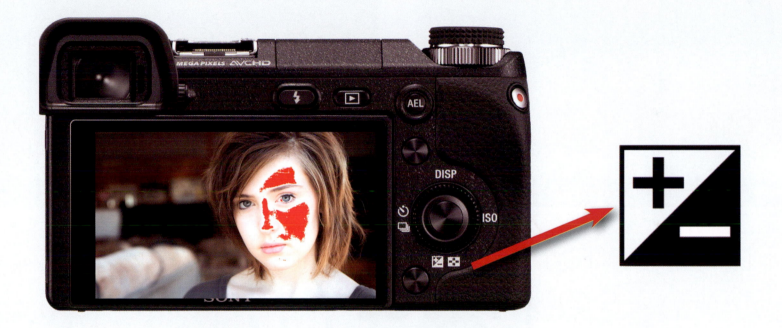

'Blinkies' (highlight overexposure warning) may be an option when reviewing images on the camera's LCD screen. Blinkies can be pessimistic as there is usually a little more detail in the highlights when reviewing the Raw image in Photoshop.

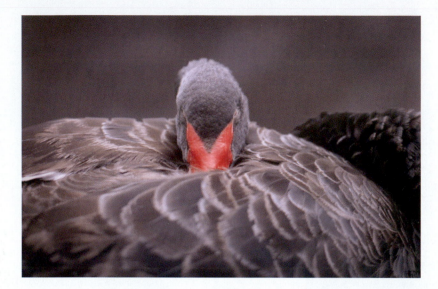 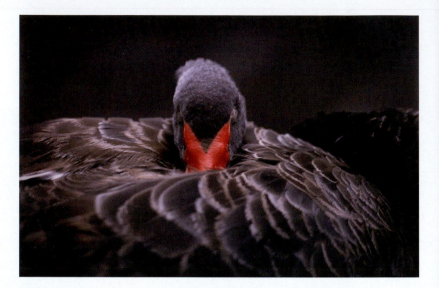

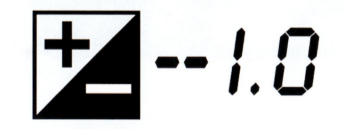

Compensation is needed to render black swans black...

±1.0

...and white walls white.

To master the craft of photography you need to practice achieving correct exposure in camera and not in Photoshop.

Note > Many cameras have a habit of underexposing by approximately 1 stop when using the Raw file format. If you find this is the case, adjust your exposure compensation dial to +1.00 …but watch out you don't overexpose or 'clip' the bright highlights.

Creative Challenges

Creative Challenge 1

People

Alysha Gaden

Creative Challenge One

Create four close-up portraits where the eyes are sharp and the background is blurred.

Zoom your lens to an 'equivalent' focal length of 50mm to 70mm (see *Full Frame Equivalent*), set the ISO to Auto and choose a wide aperture, e.g. f/4.*

*Note > Some kit zoom lenses will only open to a maximum aperture of f/5.6 when zoomed to 50–70mm. If this is the case with your lens, use the widest aperture. When using a crop sensor, e.g. APS-C, 4/3-inch or 1-inch set the aperture to f/2.8 if available (see '*Depth of Field*' in the Technical Section).

SAIFFER *Settings*

Set up your camera with the following settings:

Shutter Speed: Use 1/60 sec or faster (using slower shutter speeds may result in subject blur).

Aperture Priority: Use f/4 for full frame sensors or f/2.8 for crop sensors. Use the maximum aperture if your lens does not open to these wider apertures.

ISO: No higher than 800.

Focus and **F**ocal length: 50–70mm (equivalent) and ensure the eyes are sharp.

Exposure: Ensure there is no loss of detail in shadows or highlights (adjust if required by reviewing the histogram on the camera).

Raw: Set the 'Quality' to Raw.

John

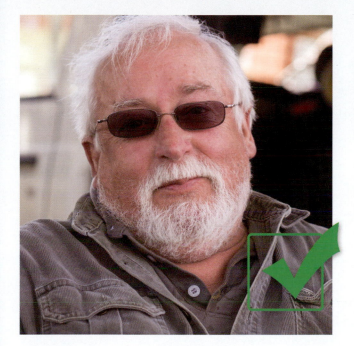

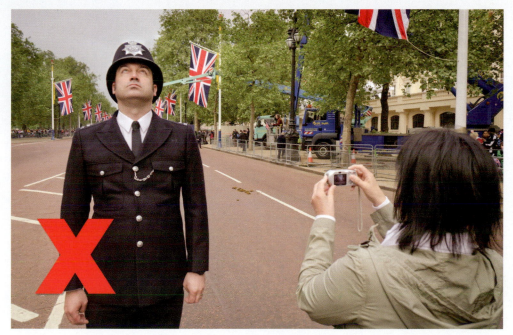

YES

NO

Step 1: Choose your subject

Choose a subject that is compliant (happy to pose) not candid (camera unaware).

Image marked with a red X is not necessarily a 'bad' image, it just does not conform to the technical requirements for this challenge.

Interacting with People

If the person is a relative stranger, strike up a conversation before asking permission to take their photograph.

1. Introduce yourself.
2. Invite them to tell you their story by asking some open questions.
3. Express an interest in their appearance or their activity.
4. Let them understand your photographic intentions are honorable and non-threatening.

Consider phrasing your desire to take a photograph in a way that will most likely lead to a positive response, such as...

"You won't mind if I create a few photographs of you, will you?"

Joe, a collaborative portrait - shared not taken

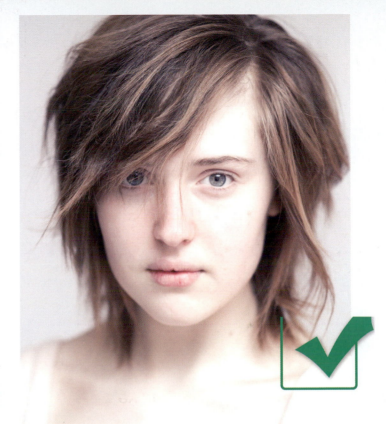

Step 2: Choose your location and background

Choose window light (with no direct sunlight), a bright cloudy day or shade outdoors. Avoid harsh sunlight as this can lead to loss of detail in the shadows or highlights. If there is not enough light to meet the technical requirements of this challenge (ISO, aperture and shutter speed) choose a brighter location.

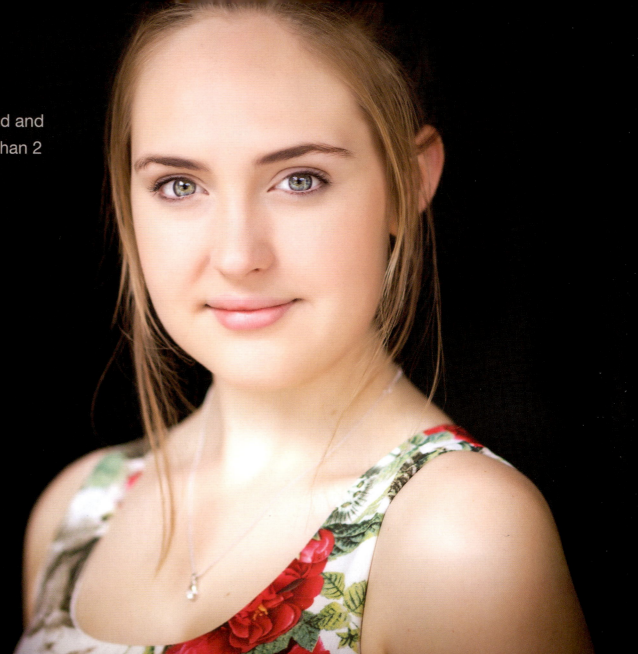

Choose a simple background and position your subject more than 2 meters (6 feet) away.

Teagan photographed in front of an open door

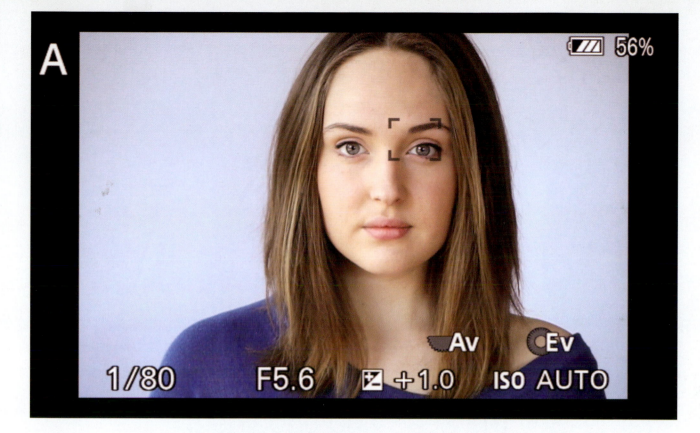

A
🔋 56%
1/80 F5.6 ☒ +1.0 ISO AUTO
Av Ev

Step 3: Apply the SAIFFER settings

Check you have adjusted the camera settings to the SAIFFER settings before asking your subject to pose. In the example above the maximum aperture of the kit lens is f/5.6. The 'exposure compensation' of +1.0 helps correct the exposure due to the presence of the bright white background (see *Exposure Compensation*).

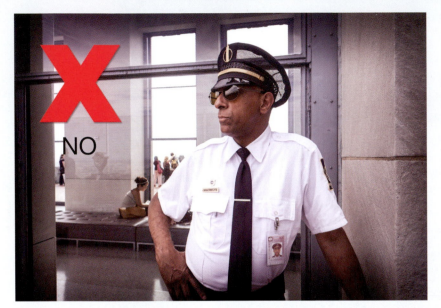

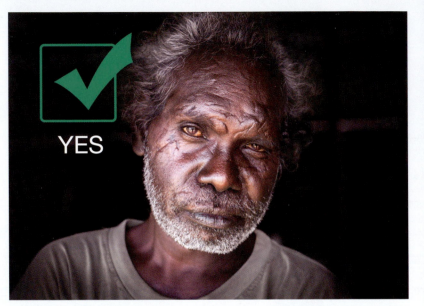

Julio Machicote – Rockefeller Buidling

Frank Murphy Munapiyawuy – Milgarri Community Elder

Step 4: Frame only the head and shoulders

Move close to your subject, ask them to remove their sunglasses and direct them to look towards the camera. Remind them that they don't need to smile for every image.

The image marked with a red X is not necessarily a 'bad' image, it just does not conform to the technical requirements for this challenge.

Wide apertures at close range = shallow focus

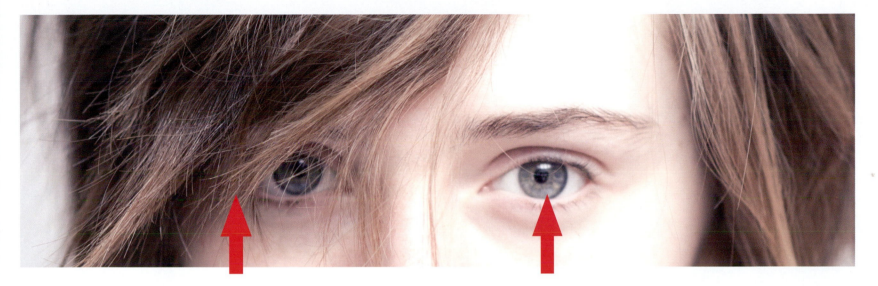

Sharp Not Sharp

Step 5: Ensure you have accurate focus on the eye

When using a wide aperture and having moved close to your subject, you must double-check your focus. The most difficult skill to master in this challenge is to focus accurately on the eye. You could 'Zoom in' to check you have accurate focus or use a 'Focus Magnifier' feature (if available) when using Live View or Image Review. Refer to *Focus Settings* in the *Technical Section* to master this skill.

Depth of Field Calculator show advanced

Camera Type	35 mm (full frame)
Selected Aperture	f/4
Lens Focal Length	70 mm
Focus Distance	1 meters

CALCULATE

Nearest Acceptable Sharpness: **0.98 m**
Furthest Acceptable Sharpness: **1.02 m**
Total Depth of Field: **0.05 m**

← 0.05m = 50mm (not even enough to ensure sharp focus from nose-to-ear at 1 meter or 3 feet)

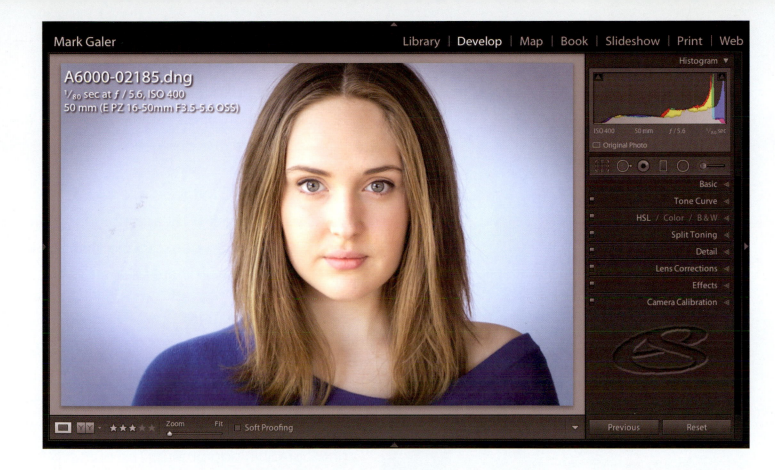

Step 6: Check SAIFFER settings and Edit

In Photoshop Lightroom, double-check that all of the camera settings conform to the criteria for this creative challenge (use the 'Self-Assessment Checklist'). Zoom in to check the eyes are sharp and then optimize your files (see the *Image Editing* section).

Ian Garadji

Skill Extension 1

If the face is at an angle, stop down one stop to f/5.6 (f/4 on a cropped sensor) and make sure the leading eye (the one nearest to you) is sharp.

Skill Extension 2

Pose your character by an open door to create a dark and blurred background that uses bright exterior light to illuminate your subject.

Skill Extension 3

If you like the effects of shallow depth of field but are struggling with the limitations of a kit lens (maximum aperture of f/5.6) then consider purchasing a 50mm f/1.8 lens to add to your photographic equipment. The 50mm f/1.8 lens is usually the most affordable lens you can purchase to extend your system. A lens with a fixed focal length (that does not zoom) is referred to as a 'Prime Lens' and are popular because of their bright maximum apertures.

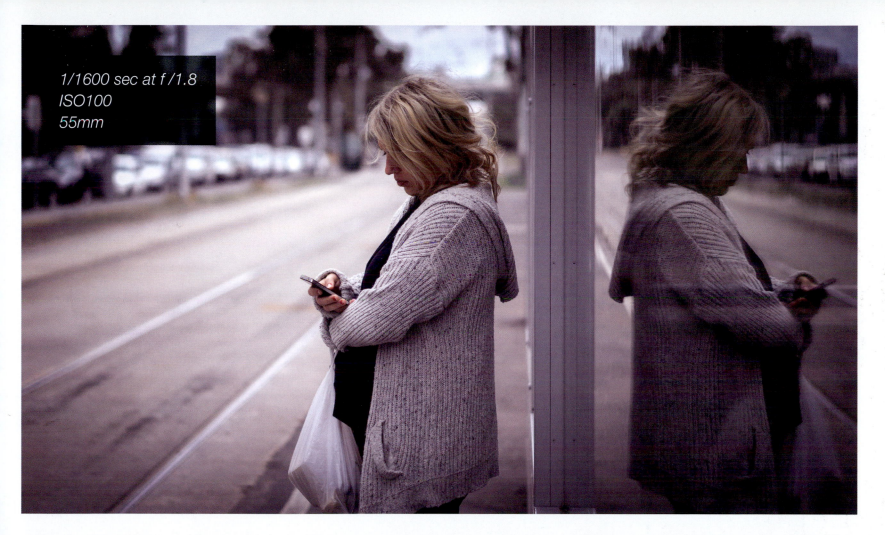

1/1600 sec at f /1.8
ISO100
55mm

When moving further away from your subject you will begin to lose the shallow depth of field you could achieve when framing a head and shoulders portrait at f/4. Opening a prime lens to f/2.8 or wider will help separate the subject from the background.

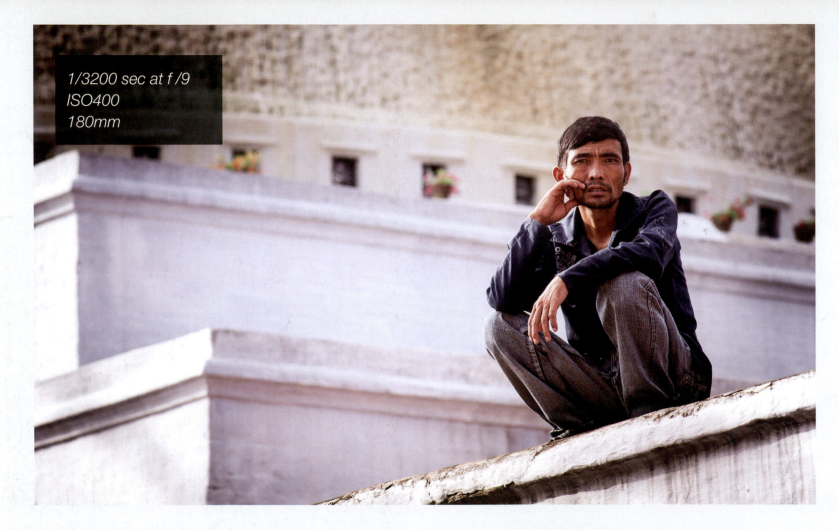

1/3200 sec at f /9
ISO400
180mm

Skill Extension 4

An alternative, to using a prime lens at a wide aperture to separate a full-length portrait from the background, is to use a telephoto lens of 135mm or longer (full-frame equivalent).

Self-Assessment Checklist for Creative Challenge One

IMAGE	Shutter 1/60 second or faster	Aperture f/4 or f/5.6 (Full Frame Sensor) - f/2.8 or f/4 (Cropped Sensor) or widest possible	Iso ISO is 800 or less	Focus & Focal Length Eyes Sharp (leading eye if head is at an angle to the camera). Use a focal length of 50–70mm (full-frame equivalent)	Exposure Achieve correct exposure in camera (Exposure slider must not be raised more than +1.00 in Lightroom)	Raw Raw file format selected in camera and exported as a DNG file in Lightroom
1						
2						
3						
4						
	Subject posed for camera (not candid)	Background Blurred	Head and shoulder framing composed in camera	Soft lighting used (not sunlight)	Essential Adjustments* and Whites and Blacks set in Lightroom	Exported file from Lightroom as a named 6.0 megapixel DNG file
1						
2						
3						
4						

NOTE > Tick off the assessment criteria in both the top section and the bottom section for each of your images before you submit them for assessment. 10 ticks per image should get you an excellent final mark.

* See the Image Editing module for guidance on the Essential Adjustments and Exporting files.

Creative Challenge 2

Place

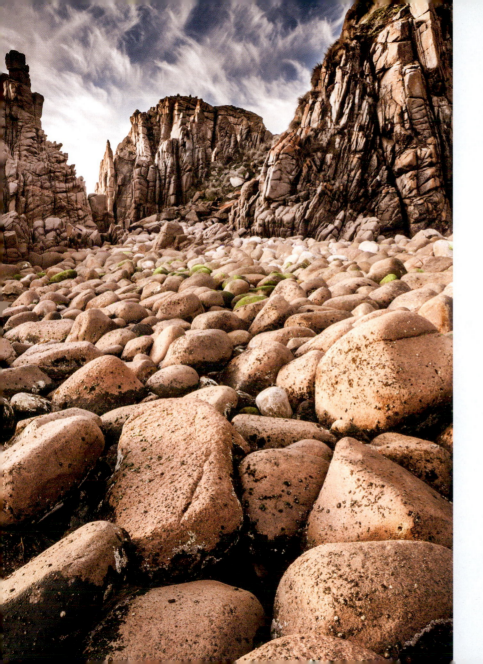

Creative Challenge Two

Compose four location or landscape images using your lens set to a short focal length (wide angle or 'zoomed out') and that has subject matter in the foreground, middle distance and distance. All subject matter must be rendered in sharp focus by your choice of Aperture.

Set the ISO to Auto and the aperture to f/16 (f/11 on a cropped 1" sensor). Photograph when the sun is low or diffused by cloud (avoid midday sun).

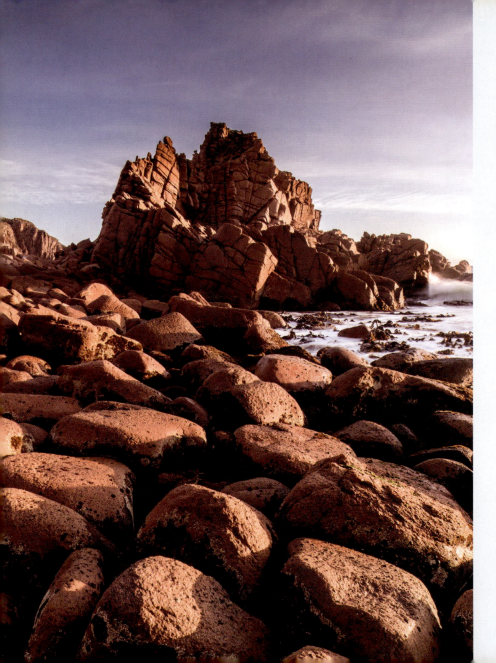

SAIFFER Settings

Set up your camera with the following settings:

Shutter Speed: 1/60 sec or faster if hand held. Only use shutter speeds slower than 1/30 second if the camera is on a tripod.

Aperture Priority: Choose f/16 on a full-frame or APS-C sensor and f/11 when using a 1 inch sensor to avoid the effects of 'diffraction'.

ISO: No higher than 800.

Focus and Focal Length: Focus approximately 2 meters (6 feet) into your subject and set the Focal Length to 24–28mm equivalent.

Exposure: Ensure there is no loss of detail in shadows or highlights (adjust if required by reviewing the histogram on the camera).

Raw: Set the 'Quality' to Raw.

Photograph when the sun is low in the sky to explore the effects of light and shade

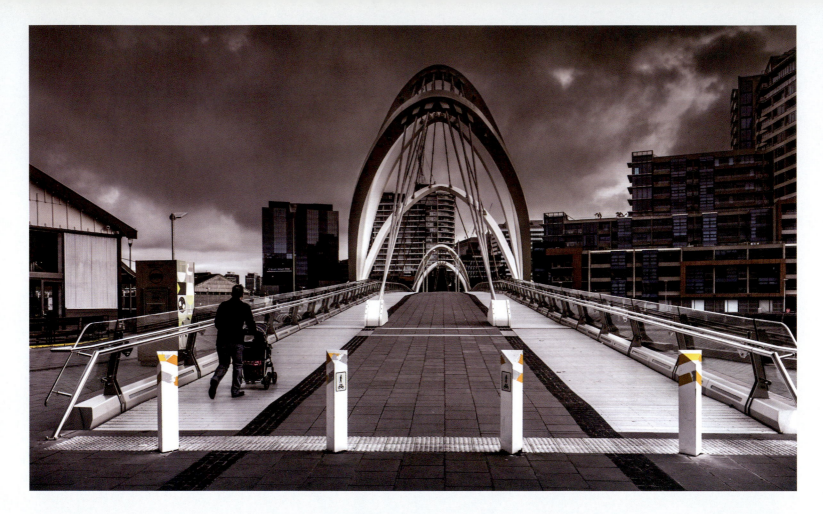

Step 1: Choose your location

Choose a location that you can revisit on different days and at different times of the day. This challenge is about capturing a 'sense of place'. The location may include people but the location is your primary subject.

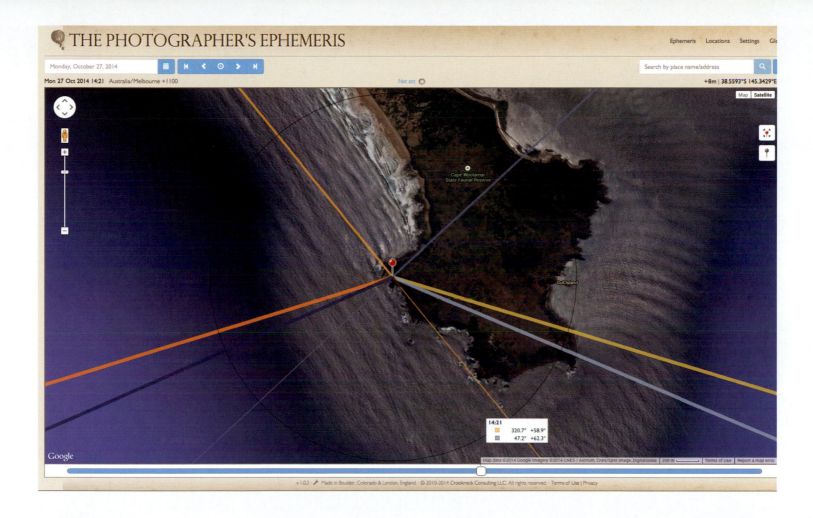

Websites such as 'The Photographer's Ephemeris' (http://app.photoephemeris) and mobile apps such as 'SunSeeker' will enable you to scout your chosen location so that you can see the position of the sun at any given time of the day.

Step 2: Explore multiple vantage points at the same location

Plan on spending several hours at your location at two different times of day, e.g. early in the morning just after sunrise and just before sunset (often referred to as the 'Golden' or 'Magic Hour'). If you have access to a tripod you may choose to capture images during the twilight period when the sun is below the horizon.

Step 3: Compose

Framing the foreground in your image will help the viewer gain a 'sense of place'. Using a wide angle (short focal length) and a low 'vantage point' will help you capture the foreground. This foreground helps the viewer gain a sense of where you, the photographer, are situated in relation to the location.

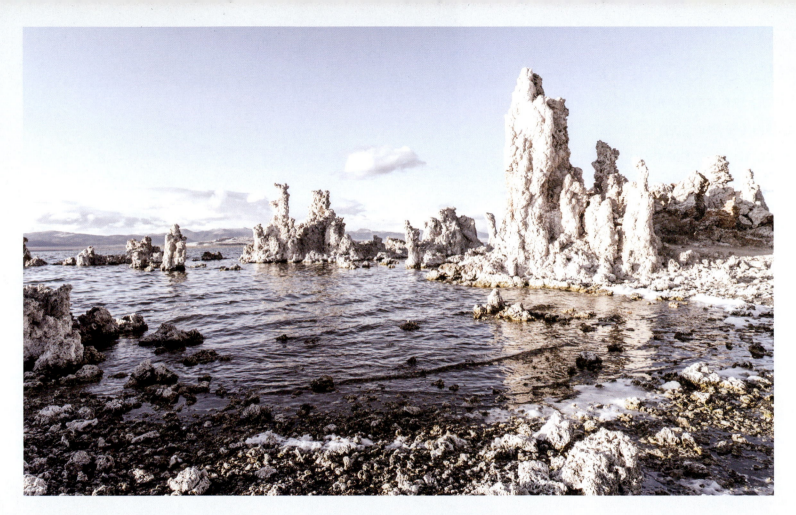

Step 4: Apply the SAIFFER settings

Apply the SAIFFER settings and if you are using a tripod and slower shutter speeds consider using the time-delay function on your camera or a remote release.

You can maintain sharp focus throughout your scene by focusing at a distance of 2 meters (6 feet) or less.

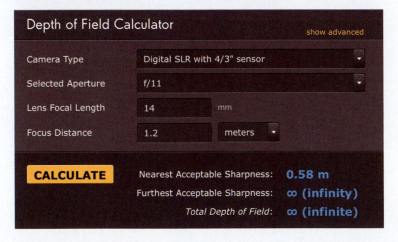

Depth of Field Calculator — show advanced

Camera Type	35 mm (full frame)
Selected Aperture	f/16
Lens Focal Length	28 mm
Focus Distance	1.8 meters

CALCULATE

Nearest Acceptable Sharpness: **0.83 m**
Furthest Acceptable Sharpness: **∞ (infinity)**
Total Depth of Field: **∞ (infinite)**

Depth of Field Calculator — show advanced

Camera Type	Digital SLR with CF of 1.5X
Selected Aperture	f/16
Lens Focal Length	18 mm
Focus Distance	1 meters

CALCULATE

Nearest Acceptable Sharpness: **0.49 m**
Furthest Acceptable Sharpness: **∞ (infinity)**
Total Depth of Field: **∞ (infinite)**

Depth of Field Calculator — show advanced

Camera Type	Digital SLR with 4/3" sensor
Selected Aperture	f/11
Lens Focal Length	14 mm
Focus Distance	1.2 meters

CALCULATE

Nearest Acceptable Sharpness: **0.58 m**
Furthest Acceptable Sharpness: **∞ (infinity)**
Total Depth of Field: **∞ (infinite)**

In these three examples of cameras with different sensor sizes, the 'equivalent' focal length is the same (28mm).

Notice how close you can focus at these smaller apertures while keeping sharp focus all the way to 'infinity'. The aperture of the 4/3" sensor is set to f/11 to avoid diffraction (a softening of sharp detail when using cropped sensors at very small apertures).

http://www.cambridgeincolour.com/tutorials/dof-calculator.htm

Step 5: Check SAIFFER settings and Edit

In Photoshop Lightroom, double-check that all of the camera settings conform to the criteria for this creative challenge (use the 'Self-Assessment Checklist'). Zoom in to check the foreground and background are sharp and then optimize your files (see the *Image Editing* section).

Skill Extension 1

When photographing in the golden hour don't focus your attention only on the sun. Pay attention to the effects that the sunlight is having on your location. Observe the light and the shadows.

Skill Extension 2

To create dramatic landscape images explore the possibility of purchasing an ultra wide-angle lens (focal lengths shorter than 24mm), a tripod and a remote release.

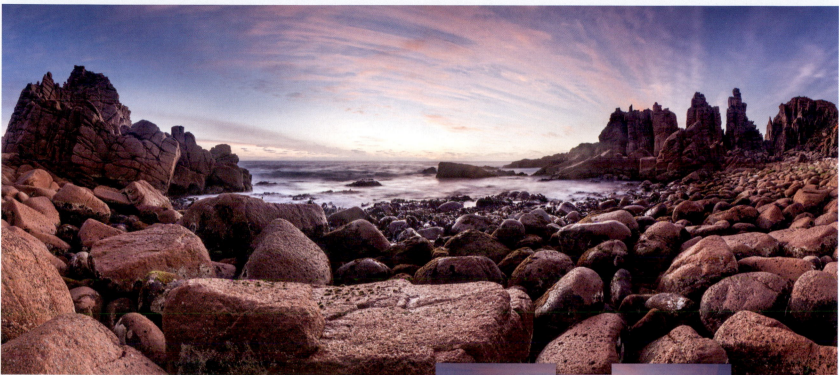

Skill Extension 3

If you do not own an ultra wide-angle lens try taking several images and stitching them together as a panorama in Photoshop CC or Photoshop Elements (Lightroom cannot perform this task). Capture the images in vertical format and use a 50% overlap.

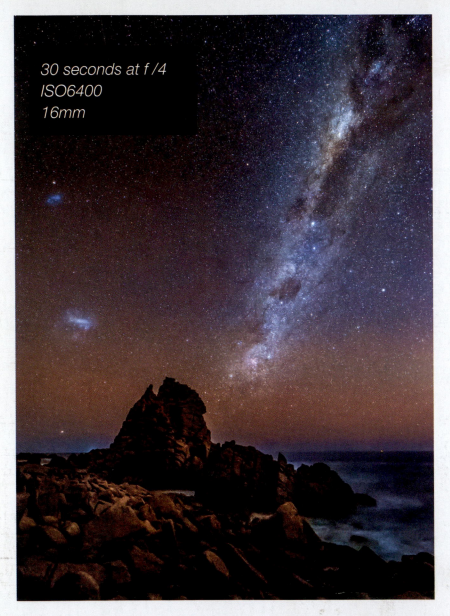

30 seconds at f /4
ISO6400
16mm

Skill Extension 4

Capturing images of the stars is a difficult, but rewarding, skill to master. You can use a mobile app such as StarWalk to locate where the galaxy (Milky Way) will appear in the night sky. It helps to choose a location that is far away from the light pollution around our cities and towns. Choose a night where the moon has not yet risen and remember to pack a torch and some warm clothes.

The camera equipment and camera settings that usually give the best results are a wide-angle lens with an aperture of f/2.8 or wider (use the widest aperture). Set the ISO to either 3,200 or 6,400 and use a shutter speed of 20 seconds or longer. On most lenses the stars will not appear sharp at infinity, so you need to take a test image, review the image at magnified view and then fine-tune the focus until a subsequent test image achieves sharp focus. Go to http://www.lonelyspeck.com for additional information.

Self-Assessment Checklist for Creative Challenge Two

IMAGE	Shutter 1/60 second or faster unless camera is on a tripod	Aperture f/16 (Full Frame and APS-C Sensor) - f/11 (1 inch Sensor)	Iso ISO is 800 or less	Focus & Focal Length Foreground and background sharp. Use a focal length of 24–28mm (full-frame equivalent)	Exposure Achieve correct exposure in camera (Exposure slider must not be raised more than +1.00 in Lightroom)	Raw Raw file format selected in camera and exported as a DNG file in Lightroom
1						
2						
3						
4						
	Image includes foreground, middle distance and background	Image photographed early or late in the day	Images provide the viewer with a 'sense of place'	Processed in Lightroom to reveal rich detail in shadows and highlights	Essential Adjustments* and Whites and Blacks set in Lightroom	Exported file from Lightroom as a named 6.0 megapixel DNG file
1						
2						
3						
4						

NOTE > Tick off the assessment criteria in both the top section and the bottom section for each of your images before you submit them for assessment. 10 ticks per image should get you an excellent final mark.

* See the Image Editing module for guidance on the Essential Adjustments and Exporting files.

Creative Challenge 3

Time

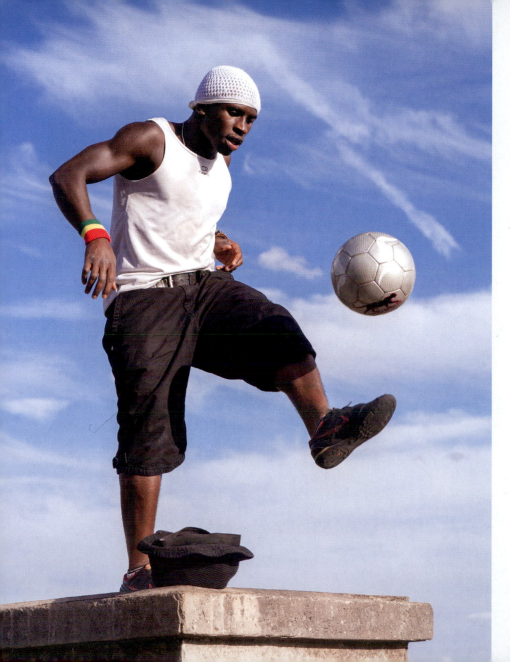

Creative Challenge Three

Create two images that freeze a moving subject using a shutter speed 1/250 second or faster and two images that create movement blur using a shutter speed 1/8 second or slower (the blur may occur because the camera is moving or the subject is moving).

With the two images that use a fast shutter speed, attempt to render the background blurred or free from distracting detail.

1/1000 Second
f/9 ISO 800

SAIFFER *Settings*

Set up your camera with the following settings:

Shutter Speed: *Shutter Priority or Tv (time value) mode. Set to 1/250 sec or faster for two images and 1/8 sec or slower for two images. Switch off Image Stabilization, Vibration Reduction or Steady Shot when 'panning'. Switch the Drive Mode to Continuous Shooting to capture multiple images.*

Aperture: *Optional – shutter speed is priority.*

ISO: *Auto. Keep below ISO 1600 if possible.*

Focus: *Use Continuous Autofocus and 'pan' the camera to follow the subject motion.*

Focal length: *Optional.*

Exposure: *Ensure there is no loss of detail in shadows or highlights.*

Raw: *Set the 'Quality' to Raw.*

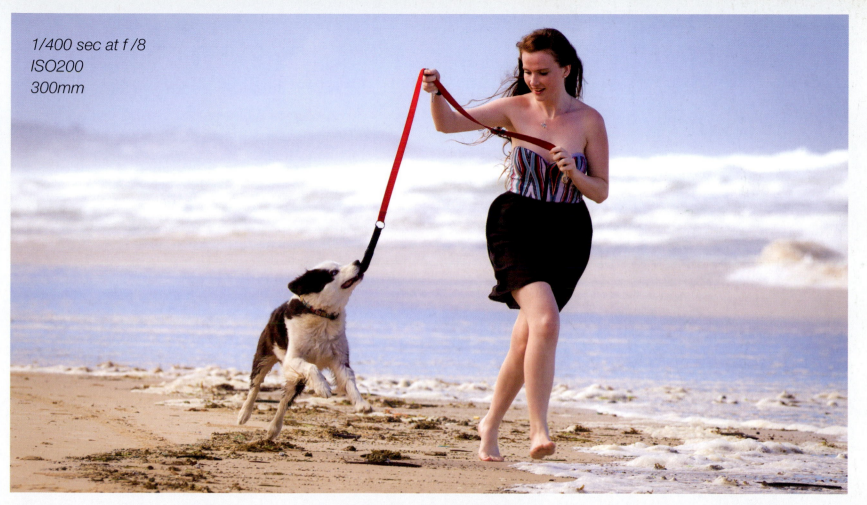

1/400 sec at f /8
ISO200
300mm

Step 1: Apply the SAIFFER settings

Check you have adjusted the camera settings to the SAIFFER settings before capturing your image.

Continuous Autofocus and Continuous Drive Mode allow you to take multiple shots in quick succession.

Step 2: High Speed

If your camera's 'focus tracking' is slow, switch to Manual Focus and choose to capture your subject as it moves through, or towards, a predetermined point of focus. Choosing fast shutter speeds will often result in wider apertures and/or higher ISO settings.

Do not expect the subject in all of your images to be sharp. With practice you may increase the number of successful images, but there will always be a percentage of missed images in this style of photography.

1/250 sec at f /7.1
ISO160
210mm

Step 3: Slow Speed

Selecting a shutter speed of 1/8 second or longer may require smaller apertures, e.g. f/16 or f/22. Allow either the movement of the subject, or your own movement, to create the required blur.

Note > Attaching a 'Neutral Density Filter' (ND) to the lens enables longer exposures in bright light. Try using a tripod and a long exposure to blur motion during twilight without an ND filter.

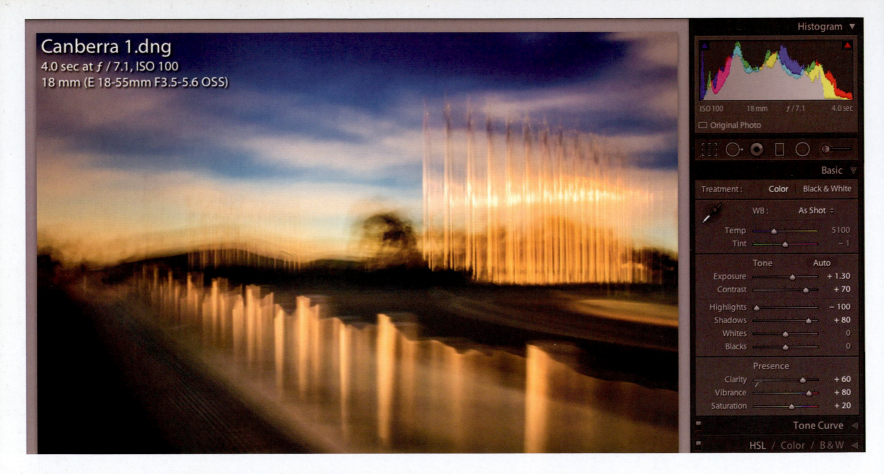

Canberra 1.dng
4.0 sec at ƒ / 7.1, ISO 100
18 mm (E 18-55mm F3.5-5.6 OSS)

Step 4: Check SAIFFER settings and Edit

In Photoshop Lightroom, double-check that all of the camera settings conform to the criteria for this creative challenge (use the 'Self-Assessment Checklist'). Zoom in to check the subject is sharp in the two high speed images and then optimize your files (see the *Image Editing* section).

Skill Extension 1

The use of a short-duration flash can help to freeze a moving subject. The maximum shutter speed that can be used with some flashes is 1/250 second. In some instances this may cause a subject to appear blurred and frozen in the same image. The blur comes from the ambient light exposure and the frozen subject via the short duration of the flash itself. This type of exposure is often referred to a slow-sync flash in the camera's menu.

With sophisticated flash units (speedlights) the photographer may have the choice to use High Speed Sync (HSS). This allows the use of shutter speeds faster than 1/250 second, so the secondary blur does not appear. The flash can also be set to a -1.00 or -2.00 stop exposure if the flash is only required to supplement the ambient light to fill or soften the shadows.

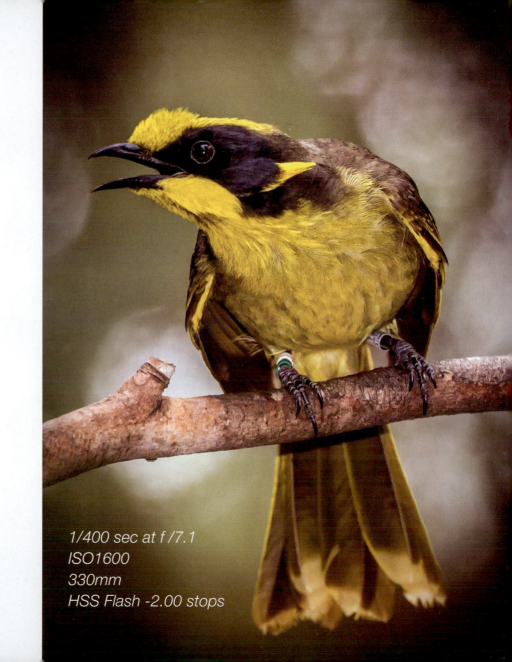

1/400 sec at f /7.1
ISO1600
330mm
HSS Flash -2.00 stops

3.2sec at f /4.0
ISO100
24mm
ND400

Canberra Airport

Skill Extension 2

The optimum shutter speed for movies is usually 1/50 second. When the video is recording at 24 to 30 frames per second (FPS) the camera is sampling approximately 50% of all motion, and the small amount of subject blur that occurs with 1/50 second helps the movie flow. Faster shutter speeds can result in movies that look 'choppy', i.e. the motion appears to flicker rather than flow. When the ambient light is bright you will need to either use a small aperture or use an ND filter if you want shallow depth of field.

Self-Assessment Checklist for Creative Challenge Three

IMAGE	**S**hutter 1/250 second or faster for two images an 1/8 second or slower for two images	**A**perture The aperture is Optional	**I**so ISO is 1600 or less	**F**ocus Focus Mode set to AF-C and the Drive Mode to Continuous **F**ocal Length Optional	**E**xposure Achieve correct exposure in camera (Exposure slider must not be raised more than +1.50 in Lightroom)	**R**aw Raw file format selected in camera and exported as a DNG file in Lightroom
1						
2						
3						
4						
	Subject or camera is moving	Shutter Priority Exposure Mode selected on camera	Use Manual Focus or AF-C (Continuous Autofocus)	Composition effective because background is blurred or uncluttered	Essential Adjustments* and Whites and Blacks set in Lightroom	Exported file from Lightroom as a named 6.0 megapixel DNG file
1						
2						
3						
4						

NOTE > Tick off the assessment criteria in both the top section and the bottom section for each of your images before you submit them for assessment. 10 ticks per image should get you an excellent final mark.

* See the Image Editing module for guidance on the Essential Adjustments and Exporting files.

Creative Challenge 4

f/8 and be there

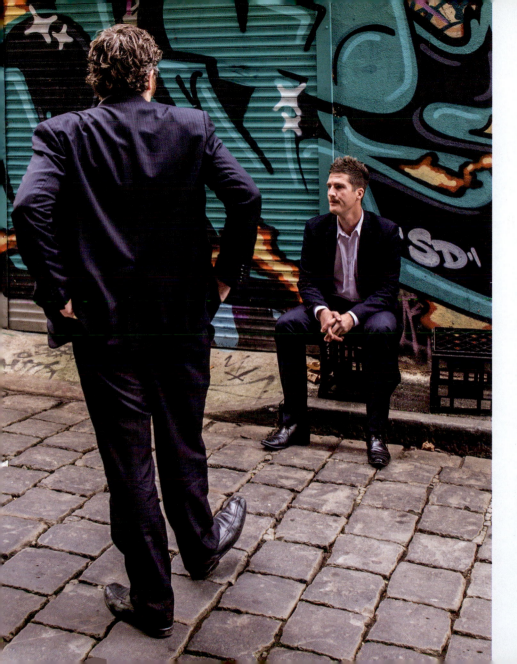

Creative Challenge Four

Capture four decisive moments (fleeting moments that would otherwise only last a few seconds) with a 28–35mm (equivalent) focal length. Your images should include one or more people. This is the 'f/8 and be there' rule and is useful for 'street photography' where 'the moment' is the priority and you may have little or no time to consider the appropriate camera settings.

Set the aperture to f/8 and then adjust either the shutter speed or ISO depending on the ambient light conditions.

These settings are optimized for 'set-and-forget' shooting, i.e. you change settings only when the lighting conditions change.

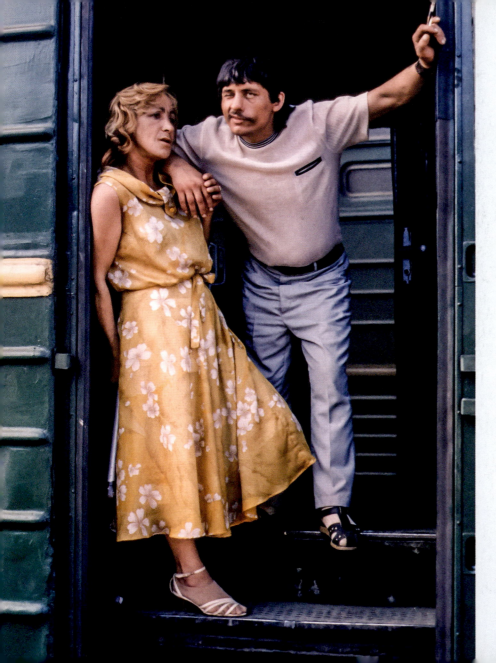

SAIFFER Settings

Use the following settings:

Shutter Speed: 1/250 second

Aperture: f/8

ISO: No higher than 3200 (see next page)

Focus: Set Focus to Manual and the Drive Mode to Continuous (for fast shutter release). Pre-focus before framing, i.e. focus on something at an approximate distance where you think the action may occur.

Focal length: 28–35mm Equivalent

Exposure: Set Mode to Manual (adjust if required by reviewing the histogram on the camera).

Raw: Set the 'Quality' to Raw.

Step 1: Learn, or print out, this guide to Manual Exposure

Lighting Conditions	Shadow Detail	Camera Settings	Exposure Guide
Sunny	Distinct	f/8 at 1/250 Sec ISO 100	Decrease ISO
Hazy or Diffused Sunshine	Soft around edges	f/8 at 1/250 Sec ISO 200	Base \| Setting
Cloudy	Barely visible	f/8 at 1/250 Sec ISO 400	
Overcast (gray clouds)	No shadows	f/8 at 1/250 Sec ISO 1600	Increase ISO
Open Shade/Sunset	No shadows	f/8 at 1/250 Sec ISO 3200	

NOTE > Minor exposure errors can be corrected in post-production. This exposure guide does not extend to Shade that is not open, e.g. alleyways, covered walkways and interiors. For the purpose of this challenge avoid capturing images in these low-light conditions.

Step 2: Learn to set a focus distance using Manual Focus

This is a great opportunity to try your hand at manual focus.

Remember f/8 will cover any minor focus errors, so long as you are using a wide-angle lens and you are not too close to your subject, i.e. all your subject is included from head to toe. Pre-focus at a distance of 2 to 3.5 meters from your subject depending on the size of the sensor in your camera.

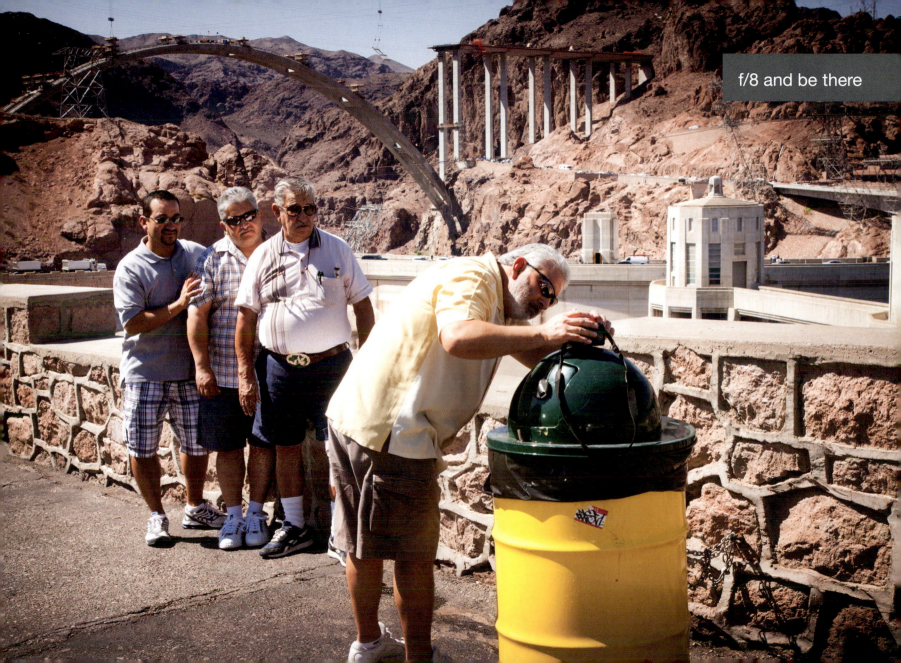

Step 3: Choose your location and subject

1. Look for a background that has a clean simple design where people are likely to move through or interact with the space.
2. For this challenge, avoid environments that are not lit by either sunlight or large open skies. You will then be working with an aperture of f/8 and only moderate ISO values.
3. Respect people's privacy. Choose subjects who expect to be photographed, are likely to be too preoccupied with their own activity to notice you or ask their permission first.
4. Move yourself in relation to the subject and the background, so that the background behind the subject is uncluttered (at f/8 you will not be able to use shallow depth of field to separate the subject from the background).
5. See the scene with your eyes first and then raise the camera only briefly to capture the image. Always lower the camera immediately if your subject looks at the camera.
6. Consider shooting from the waist. Tilt the camera's LCD screen (if this is an option)
7. Try to predict moments of interest and then shoot decisively.

Step 4: Apply the SAIFFER settings

Set the Exposure and Focus settings for your chosen location and do not re-adjust the ISO unless the lighting conditions change.

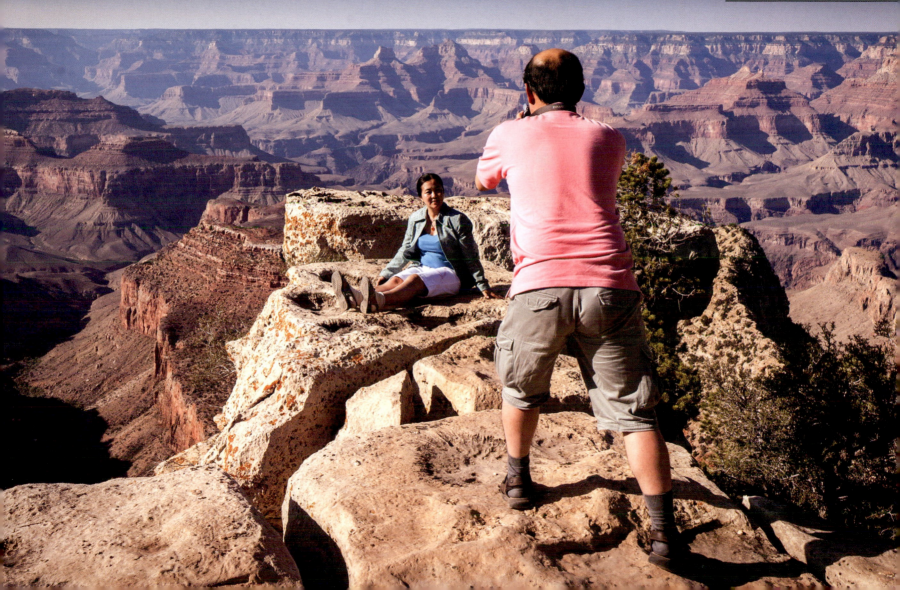

f/8 and be there

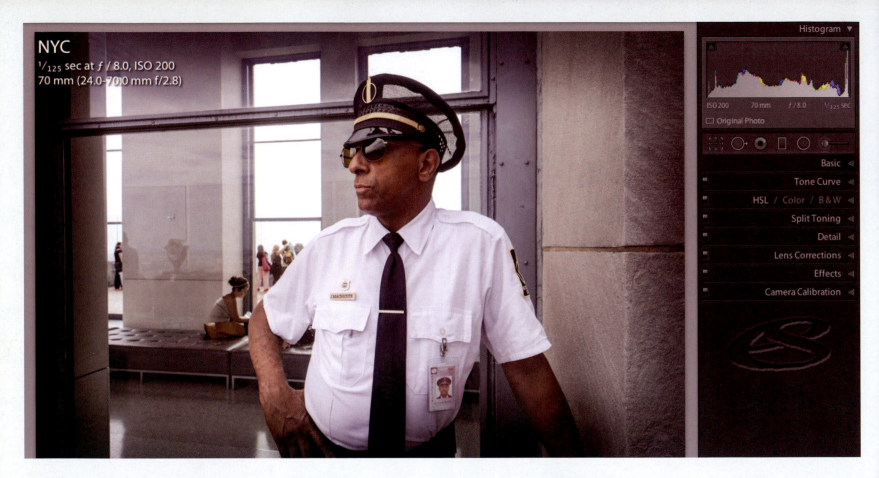

NYC
1/125 sec at f / 8.0, ISO 200
70 mm (24.0-70.0 mm f/2.8)

Histogram ▼

ISO 200 70 mm f / 8.0 1/125 sec

☐ Original Photo

Basic ◁
Tone Curve ◁
HSL / Color / B & W ◁
Split Toning ◁
Detail ◁
Lens Corrections ◁
Effects ◁
Camera Calibration ◁

Step 5: Check SAIFFER settings and Edit

In Photoshop Lightroom, double-check that all of the camera settings conform to the criteria for this creative challenge (use the 'Self-Assessment Checklist'). Adjust exposure as required to fine-tune your images (see the *Image Editing* section).

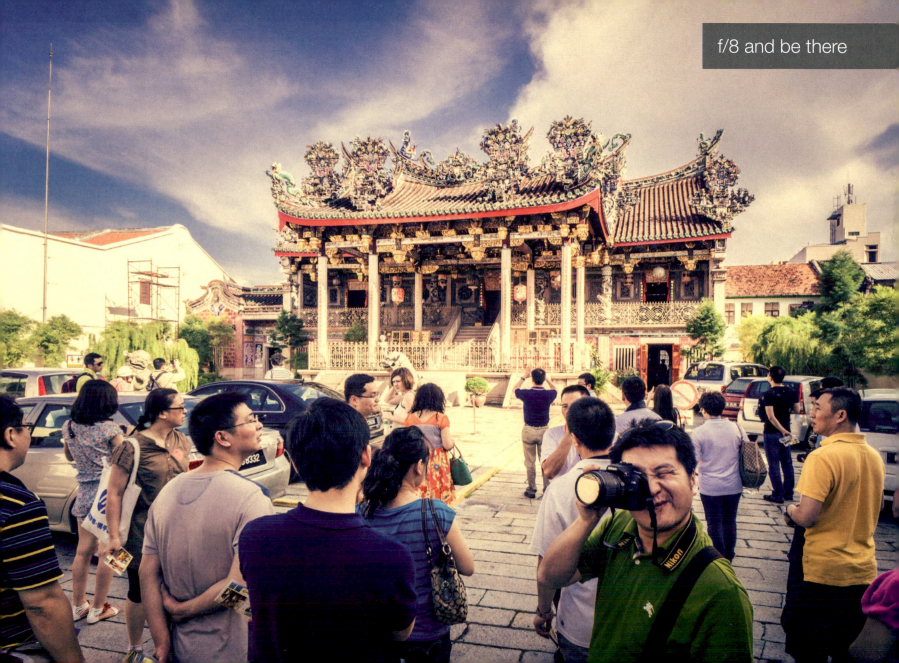

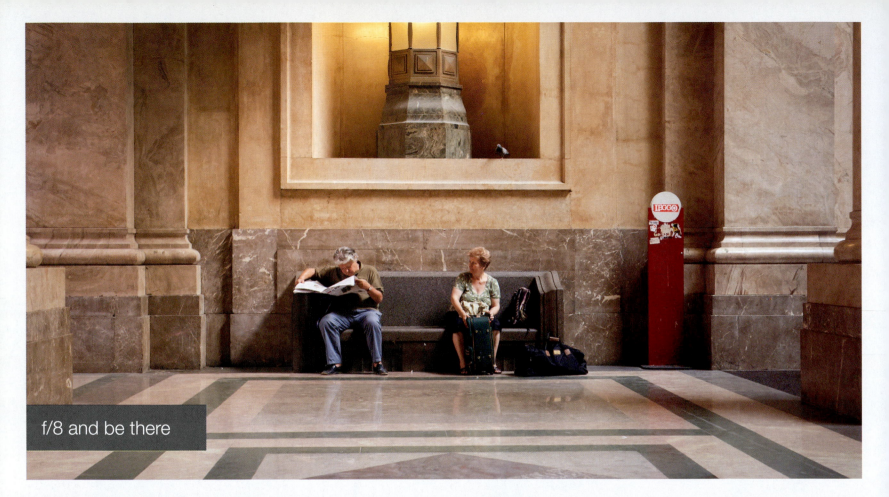

f/8 and be there

Skill Extension

In locations of low ambient light you can take an 'average' meter reading (an 18% Gray card or Exposure Reference may help) and then leave the exposure settings until the location changes. If you do not have an exposure reference check the histogram of a test image and then fine-tune the exposure settings.

Self-Assessment Checklist for Creative Challenge Four

IMAGE	**S**hutter 1/125 second or 1/250 in full sun	**A**perture f/8	**I**so ISO 100–800 depending on lighting conditions	**F**ocus & **F**ocal Length Subject sharp. Use a focal length of 28–35mm (full-frame equivalent)	**E**xposure Achieve correct exposure in camera (Exposure slider must not be raised more than +1.50 in Lightroom)	**R**aw Raw file format selected in camera and exported as a DNG file in Lightroom
1						
2						
3						
4						
	Subject or subjects NOT posed for camera	Decisive moment captured in at least two of the four images	Image photographed in conditions of open shade or brighter	Framing decision creates an uncluttered design	Essential Adjustments* and Whites and Blacks set in Lightroom	Exported file from Lightroom as a named 6.0 megapixel DNG file
1						
2						
3						
4						

NOTE > Tick off the assessment criteria in both the top section and the bottom section for each of your images before you submit them for assessment. 10 ticks per image should get you an excellent final mark.

* See the Image Editing module for guidance on the Essential Adjustments and Exporting files.

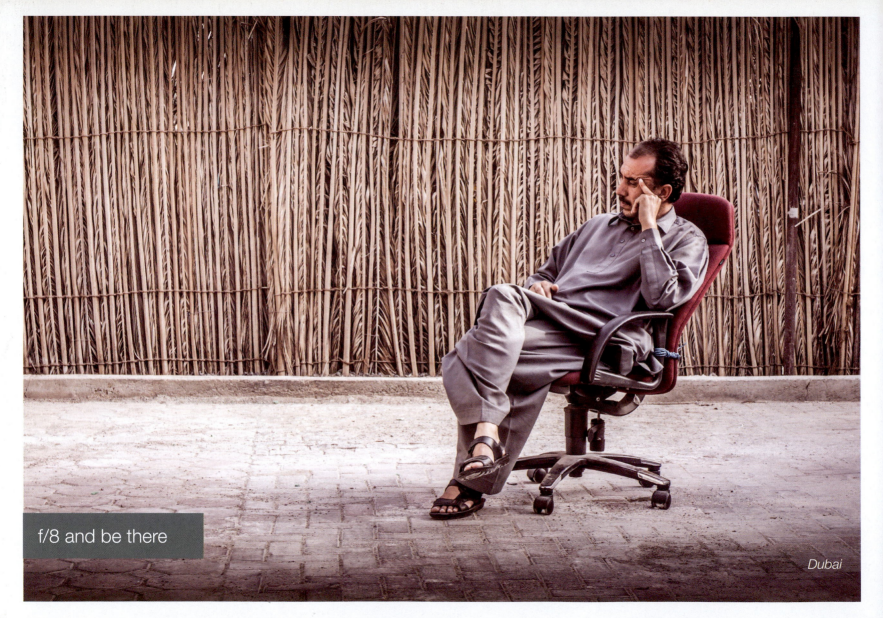

f/8 and be there

Dubai

Image Editing

Image Editing

Optimize images if required prior to submission. All images must have a white and black point assigned and have the appropriate lens corrections applied.

Basic Adjustments:

Exposure and Contrast

Highlights and Shadows

Whites and Blacks

White Balance

Vibrance and Saturation

Clarity

Optional Adjustments:

Graduated and Radial filters

Adjustment Brush

Effects (Vignette)

Essential Adjustments:

Crop and Straighten

Lens Corrections

Detail (Sharpening and Noise Reduction)

Spot Removal

Exporting Images:

Export files for Assessment

Note > The demonstration images used in this section are available from: http://adobe.ly/1caELUs

Basic Adjustments

Image Editing

Lightroom is a non-linear image editing space (the sequence of editing is of no importance) and it is also non-destructive (you can restore your images to their original state at any time).

If you are unsure where to start editing your image, begin with fixing the aspects of the image that annoy you the most, and finish with those that annoy you the least.

The 'Basic' and 'Essential Adjustments' sections cover adjustments that you should consider applying to most, if not all, of the images you have captured for your Creative Challenges. The 'Optional Adjustments' section looks at those adjustments which will help you style or 'grade' your images.

You will need to export a processed version of each image for assessment after you have edited your images

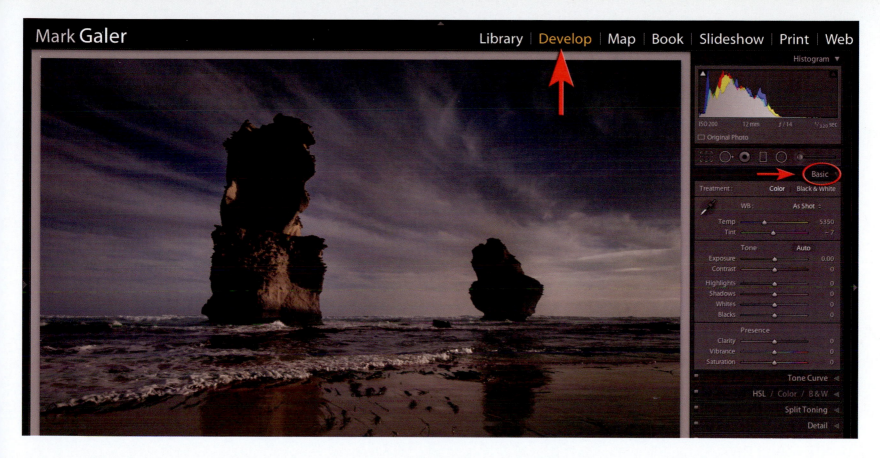

Basic Adjustments

1. Import the images from your creative challenge shoots.

2. Go to the Develop Module, which is where you will find all of the tools to optimize your images.

3. Go to the Basic Panel to start the image editing process.

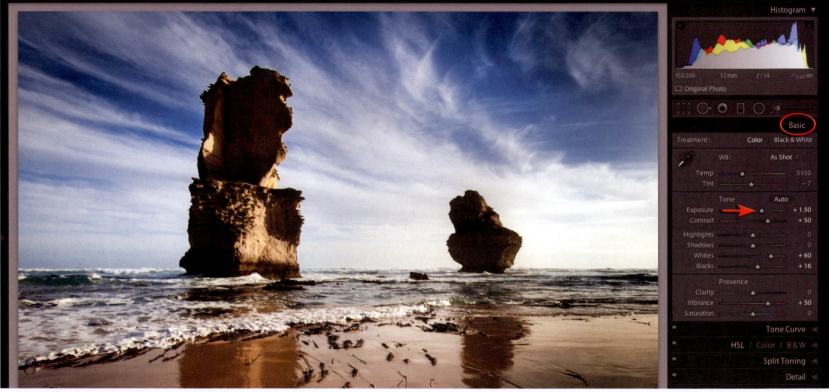

Exposure

Adjust the overall Brightness and Contrast of the image using the Exposure and Contrast sliders. Increasing the exposure value by more than +1.50 indicates the original exposure was excessively underexposed and will result in a low quality outcome if adjusted further. If this is the case consider re-shooting the Creative Challenge or choose another image.

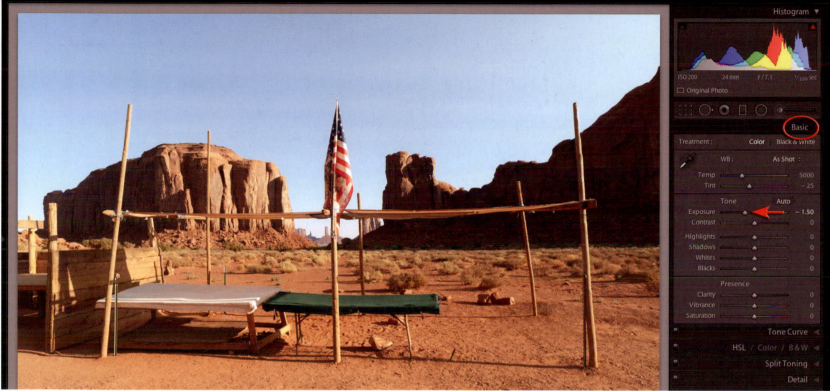

Decreasing the Exposure will not lower the quality of the image unless the brightest highlights were 'clipped' during the initial exposure in camera. The detail in a clipped highlight cannot be restored in post-production.

Highlights and Shadows

Sometimes the highlights are too bright and the shadows are too dark (sometimes both). In some instances the 'Show Shadow Clipping' and 'Show Highlight Clipping' triangles above the histogram will appear white (indicating a loss of detail in the Blacks and Whites).

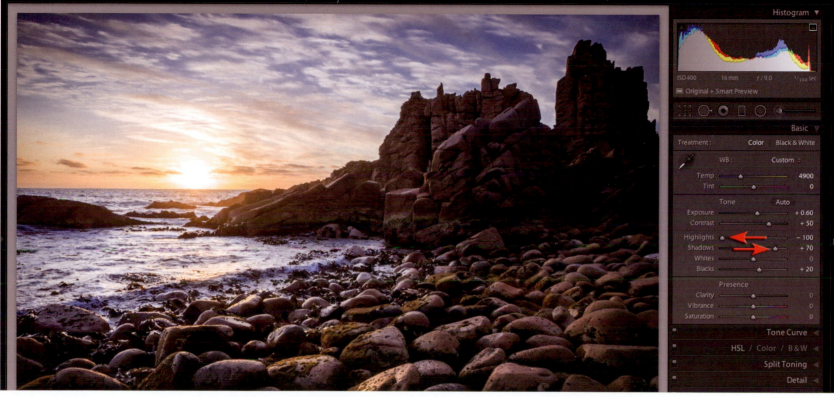

The Highlights and Shadows can be corrected using the Highlights and Shadows sliders. You may need to add Contrast and Clarity to restore a 'realistic' appearance to the tonal quality if generous amounts of both sliders are used to correct an image.

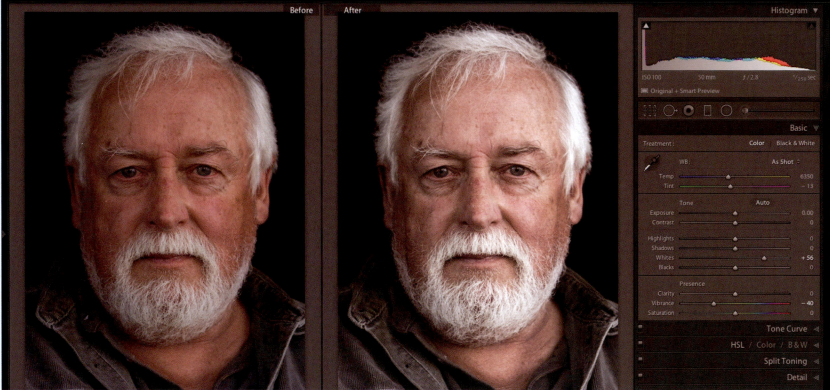

Whites and Blacks

Set both White and Black points for 99% of your images. Adjust the slides until they appear white and then move them back until they appear as a color or as black triangles. Whites is the best tool to establish bright white highlights in an image.

For images where the brightest tones are clipping, it may be necessary to reduce the Highlights slider to recover the highlight detail before setting the Whites slider.

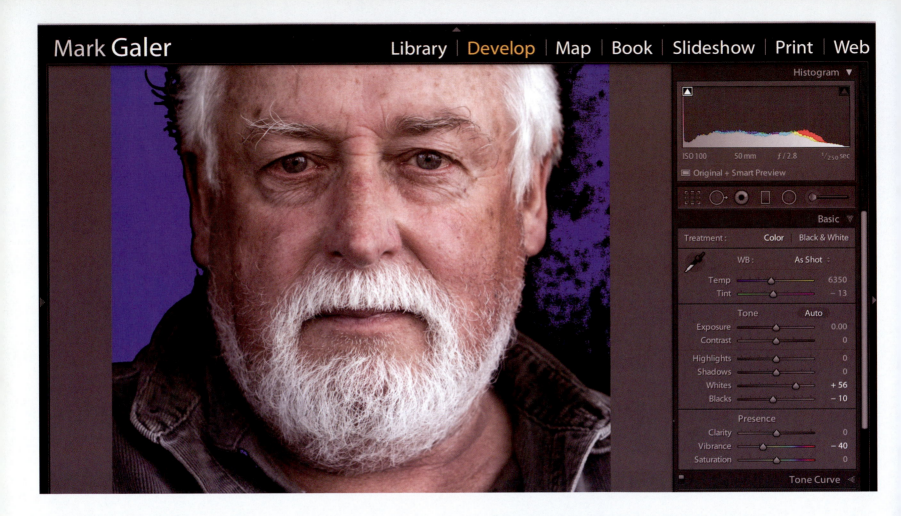

Black clipping should occur only if there is an absence of a surface (studio backdrop or cave entrance etc.). Click on either of the triangles to see where the clipping is occurring in the image preview.

Clipping the whites is OK if it is the light source or its reflection (often referred to as a specular highlight).

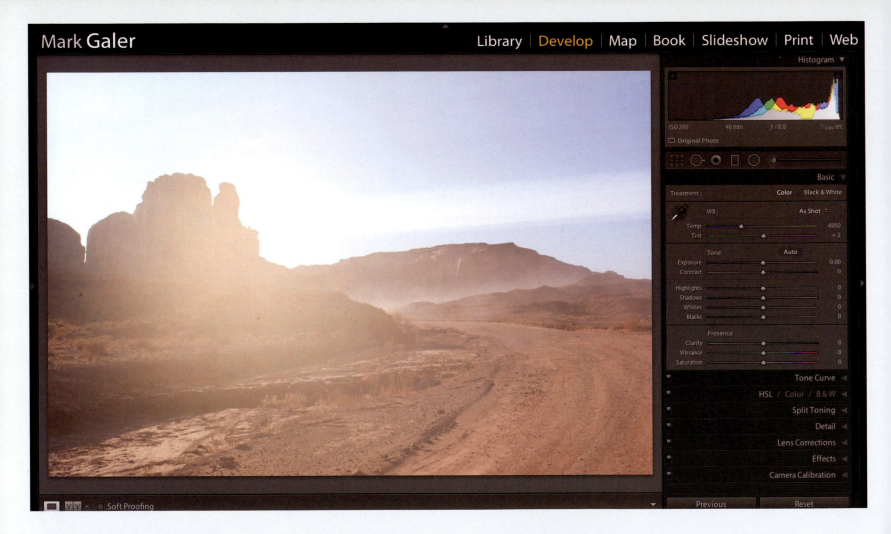

A black point often needs to be set when working with a telephoto lens or when there is dust in the atmosphere or 'lens flare' has occurred.

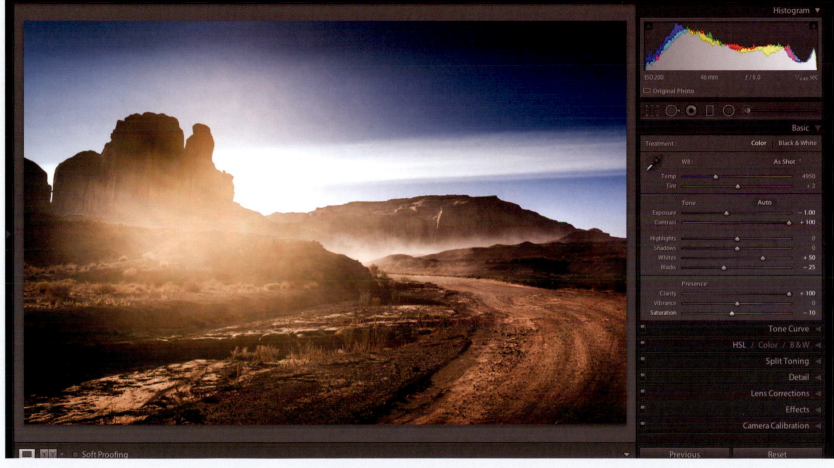

If this is the case you may need to add Contrast and Clarity to restore the 'depth' to the tonality.

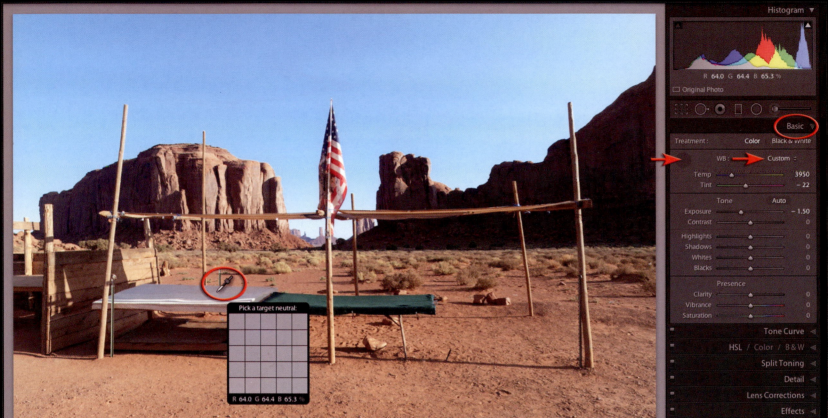

White Balance

Adjust the White Balance of the image if it appears either too warm or too cool. There are three ways of doing this. Move the Temp and Tint sliders, select an alternative white balance from the drop-down menu or click on a 'neutral' tone (a gray within your image) using the White Balance Selector.

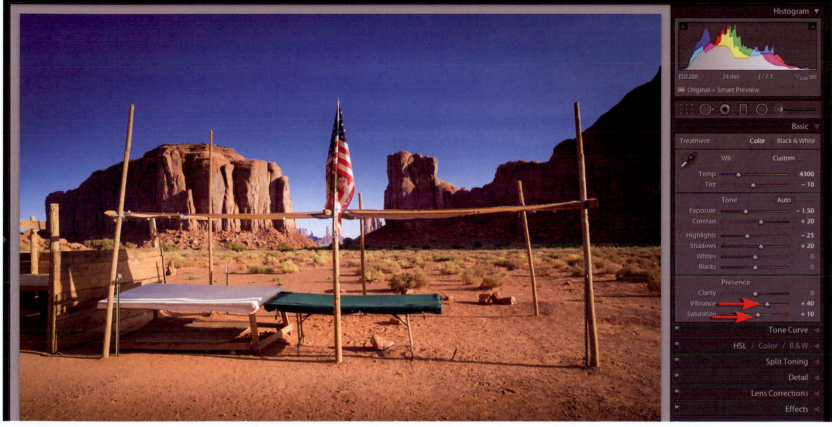

Vibrance and Saturation

Use the Vibrance slider rather than the Saturation slider to increase the saturation, as this is slow to clip individual color channels that, in turn, helps to preserve surface texture. Use the Saturation slider in moderation if you see that orange colors need more saturation than the Vibrance slider is providing.

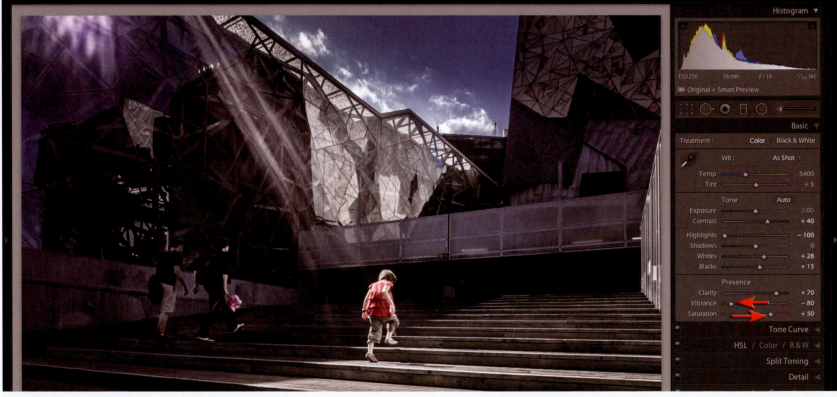

When the Saturation slider is moved all the way to the left all colors will be fully desaturated. When the Vibrance slider is moved all the way to the left, the colors in the image that were most saturated retain some of their color. If the Vibrance slider is moved to the left and the Saturation slider to the right we are left with an image where the dominant colors are retained and the rest of the colors are desaturated.

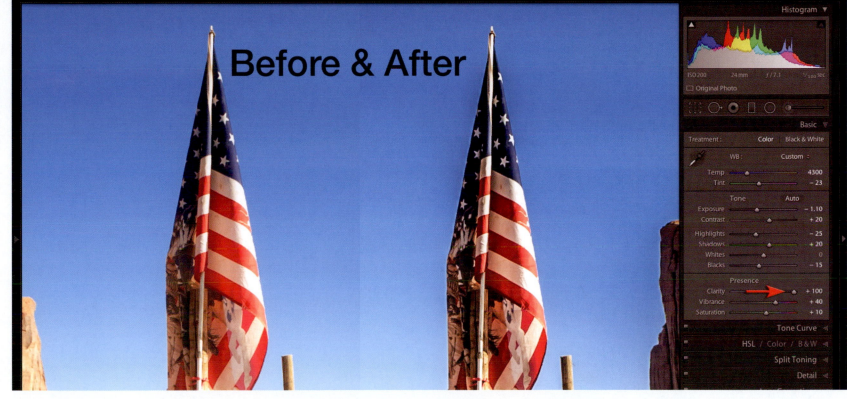

Clarity

When the Clarity slider is moved to the right mid-tone contrast in the image increases. This can introduce more apparent surface texture and more depth to an image. When too much Clarity is added halos of dark or light tone may be visible alongside high contrast edges. Using Negative clarity in Lightroom rarely produces an effect which is deemed attractive.

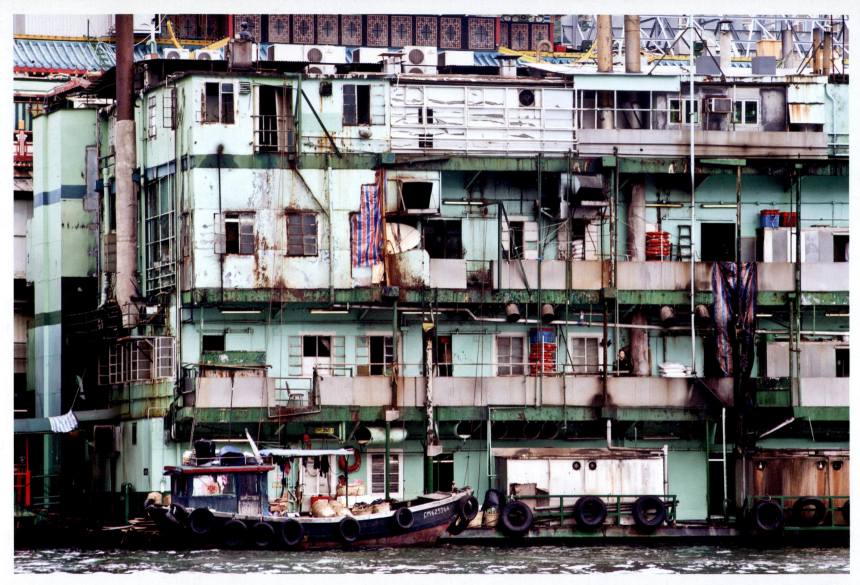

Aberdeen - Hong Kong

Essential Adjustments

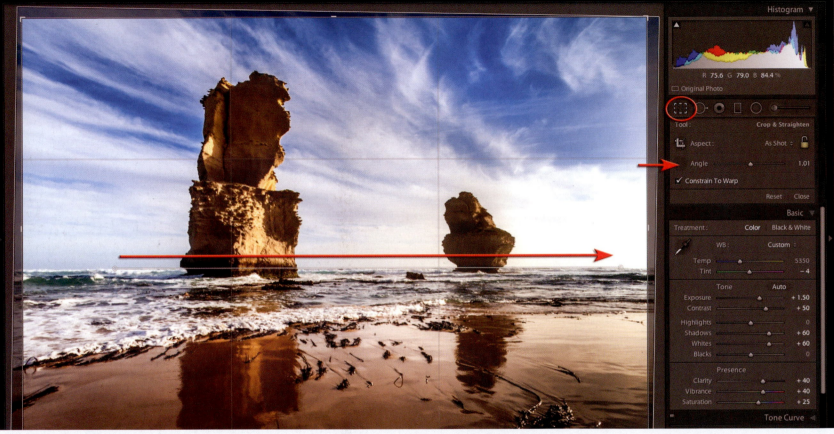

Crop and Straighten

Crop the image using the Crop Tool (R) to optimize the framing or to straighten a crooked image.

Select the Straighten Tool and drag along a horizontal or vertical line to correct a crooked image.

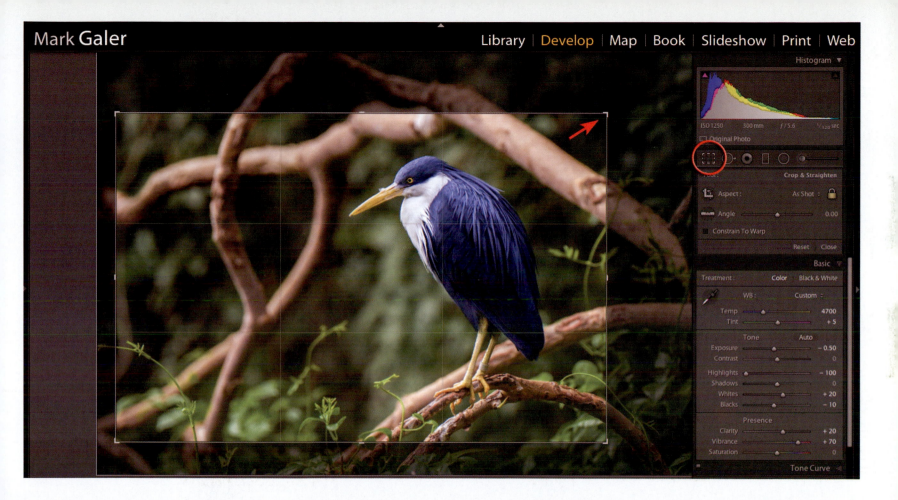

Crop to perfect the composition, e.g. moving the focal point off-center or removing distracting detail from the edges or...

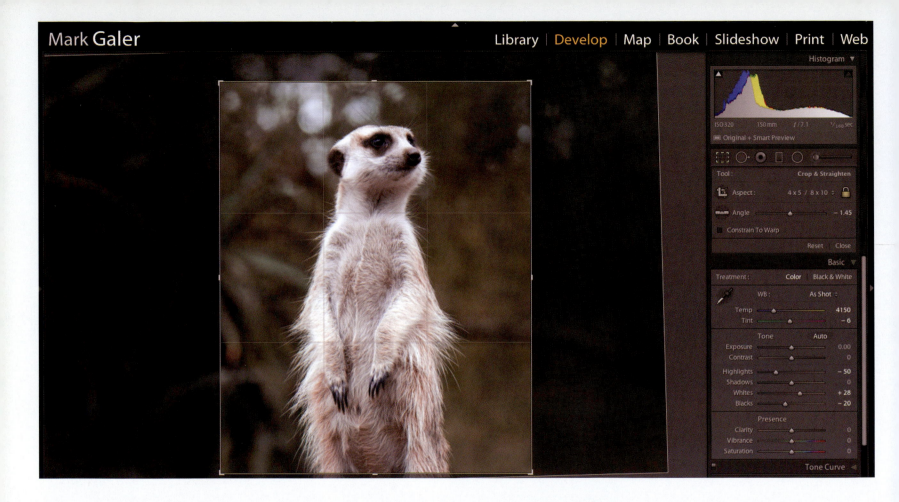

…crop a Horizontal format image into a Vertical format image.

Note > Do NOT crop (remove) more than 60% of the original image (to retain a high resolution image).

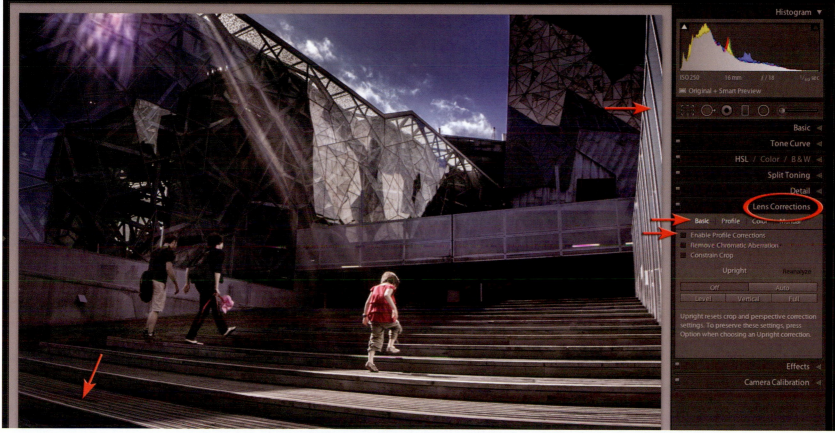

Lens Corrections

Remove lens distortions: Go to the Lens Corrections panel and click on the Enable Profile Corrections checkbox in the Basic tab. This action will remove the lens distortions that cause straight lines to bend.

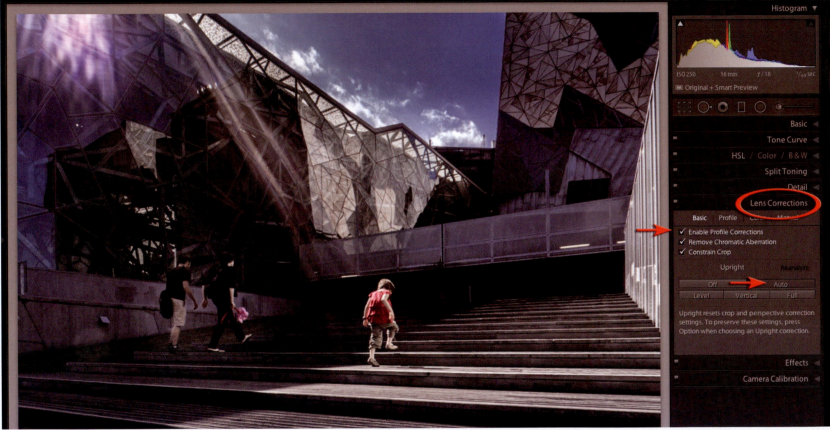

Try clicking on the Auto button in the Upright section of the Basic tab if the verticals in the image are converging excessively (a result of tilting the camera up or down when using a wide-angle lens).

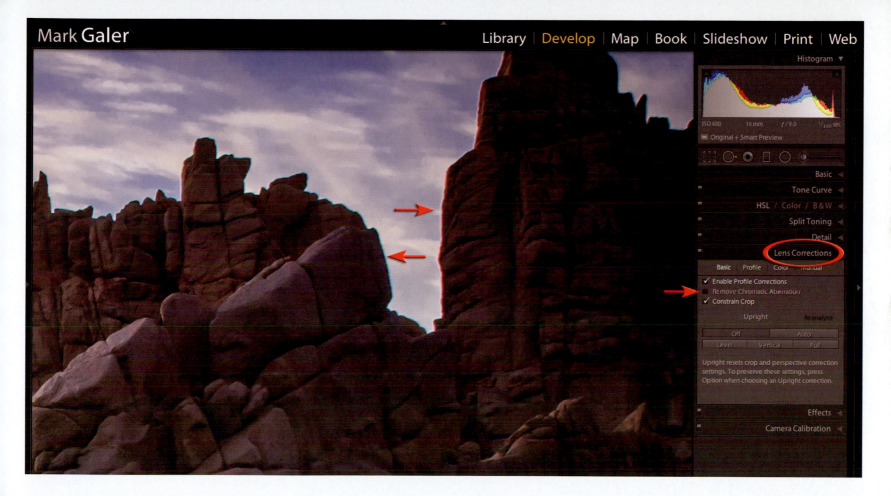

If you have used a wide-angle lens, check the Remove Chromatic Aberration checkbox. Chromatic Aberration refers to the colors that can be seen along high contrast edges (in the corners of the image) with images captured using a short focal length lens (wide-angle).

When the Remove Chromatic Aberration checkbox is checked these colors will mostly disappear.

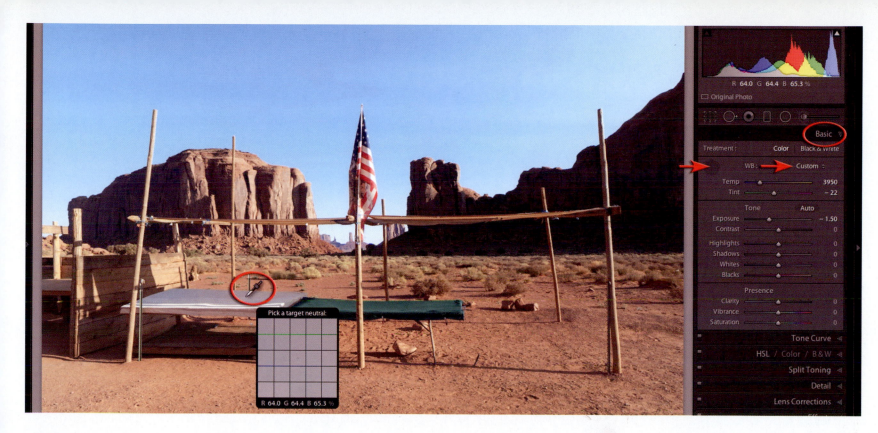

Detail: Sharpening

Sharpening is not designed to correct images that were captured out-of-focus in camera. It does, however, optimize images captured with sensors equipped with anti-aliasing filters and captured with cameras using standard quality lenses.

Go to the Detail tab, zoom the image to 1:1 and adjust the Amount slider to a value between 25 and 75. Raise the Masking slider to prevent image artifacts becoming apparent in the smoother tones.

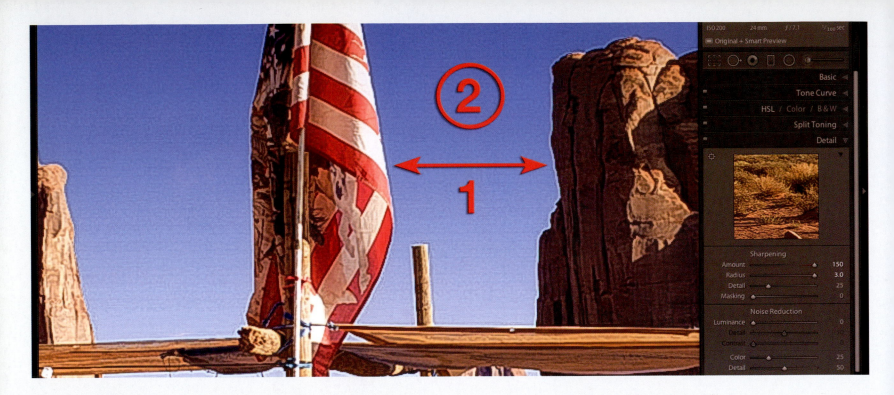

In this 200% or 2:1 magnified view we can see what happens when too much sharpening is applied and masking is not used.

1. The Amount slider defines how much contrast is applied at an edge while the Radius slider defines the width of the edge that is affected. Reducing the Amount to 75 or less and the Radius to 1.0 creates an effective sharpening workflow where the image will not appear over sharpened.

2. The areas of smooth continuous tone start to become textured as the image artifacts and noise are exposed to the sharpening process. Raising the Masking slider protects these areas from the sharpening process.

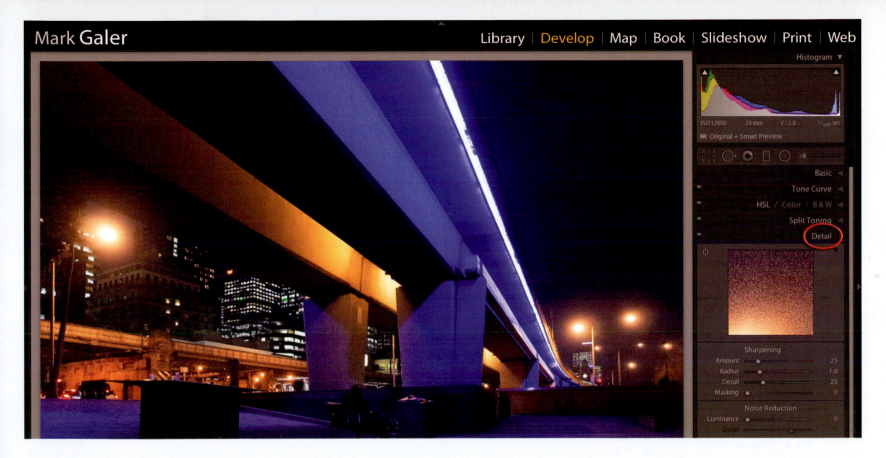

Detail: Noise Reduction

When you have raised the ISO to 800 or more it may be necessary to go to the Detail panel and remove excessive Luminance noise. Do not attempt to remove all noise from the image as the resulting tones will appear as if they are made from plastic.

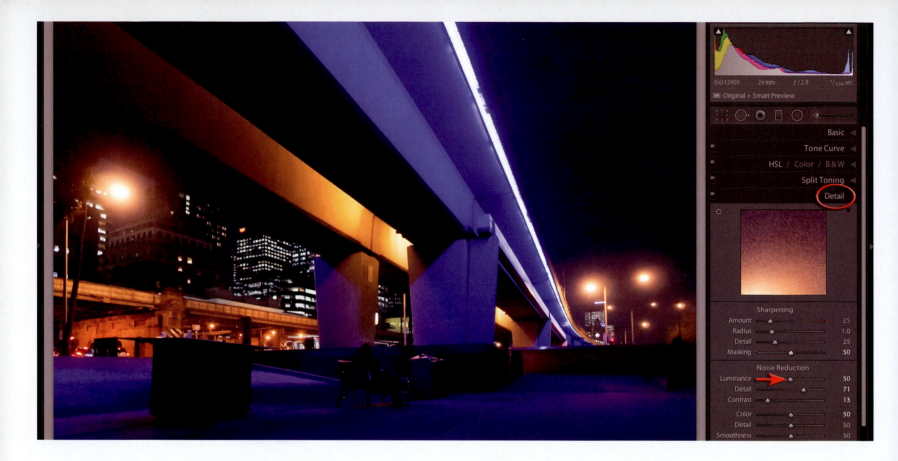

For images with excessive noise try raising the Luminance slider up to 50, the Detail slider up to 70 and the Masking slider in the Sharpening section up to 50. For images with moderate noise levels a Luminance value of 20 may suffice.

Spot Removal

Dust on the camera sensor can be clearly seen when the lens aperture is stopped down. These dust spots can be removed in post production using the Spot Removal Tool. Use the Visualize Spots option in the Toolbar to help locate the dust spots. Use a brush just larger than the dust spot and click to remove. If the source of the repair is inappropriate drag the source circle to a more appropriate area in the image preview.

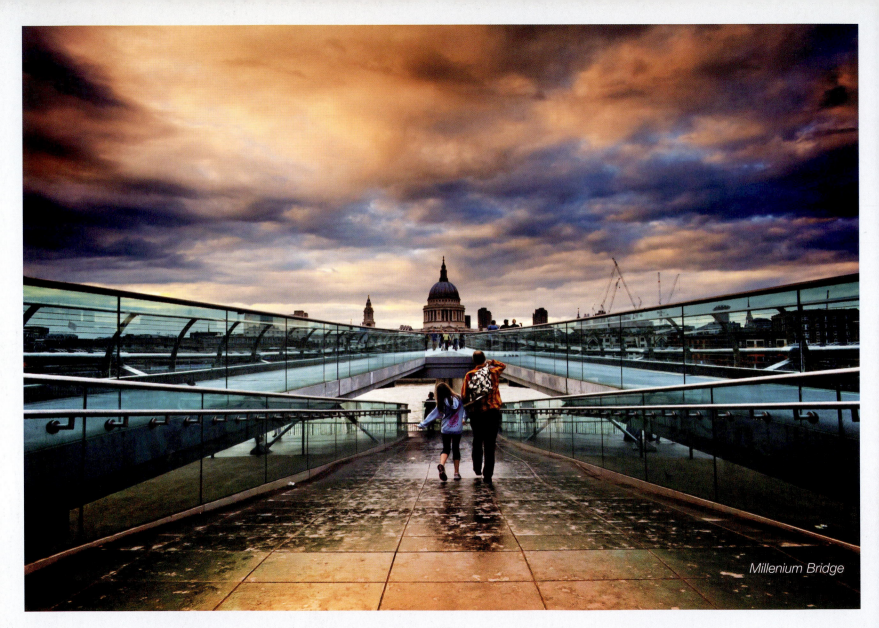

Millenium Bridge

Optional Adjustments

Graduated and Radial Filters

Graduated and Radial filters can be useful for applying a number of localized adjustments including darkening overly bright skies. In the image above the sky appears a little too bright.

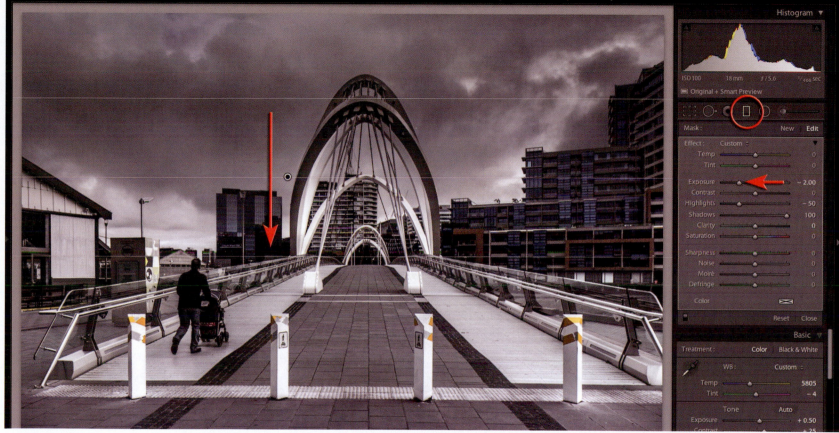

A Graduated filter is applied to the Sky, lowering both the Exposure and Highlights. The Shadows slider is raised to protect the bridge and the distant buildings from the darkened exposure.

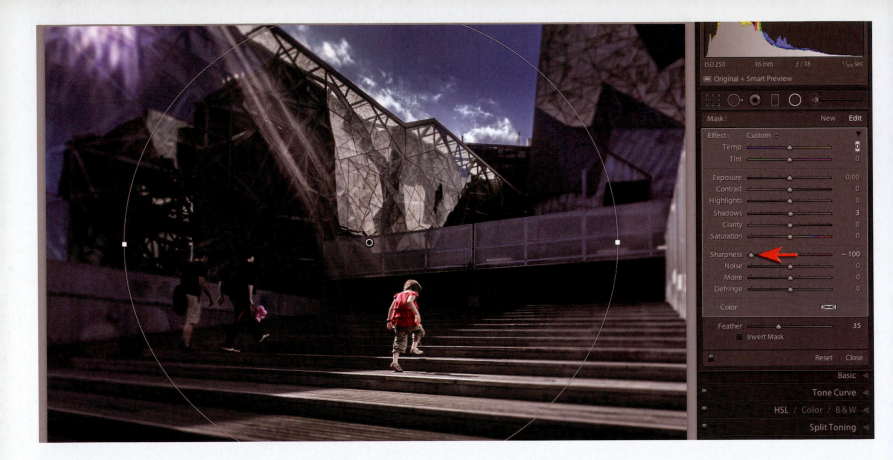

Radial Filters can be used to drop pools of light into an image to draw attention to key features. They can also be used for many other creative applications such as the one in the illustration above. The original image was captured using a small aperture and so in this example the outer edges have been defocused to help the viewer focus their attention on the girl climbing the stairs.

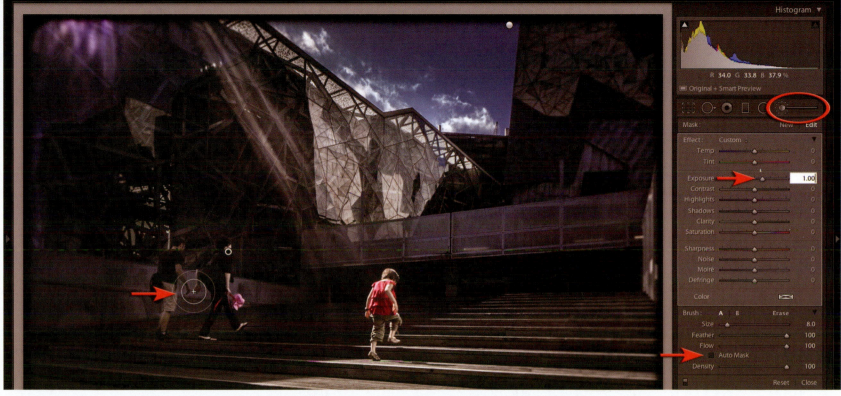

Adjustment Brushes

A range of localized changes can be made to color and tone using the Adjustment Brush. The most useful change can be made by simply making areas either lighter (dodging) or darker (burning). Raise the Feather to 100 to hide brush marks and be careful when using the Auto Mask option that the brush does not introduce artifacts along edges within the image.

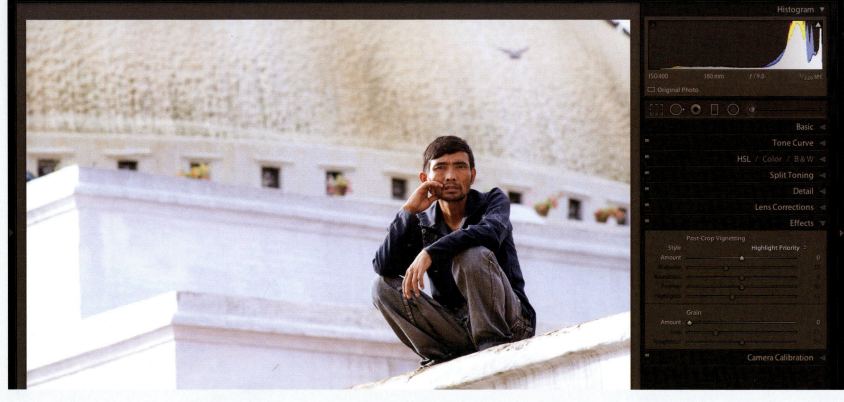

Post-Crop Vignetting (Effects panel)

I believe that approximately 50% of all photographers add a vignette to 50% of their images. Sometimes we are not aware they have been added because they are often subtle. These vignettes can draw our eye into the image and stop us from spending too much time inspecting the edges of the frame.

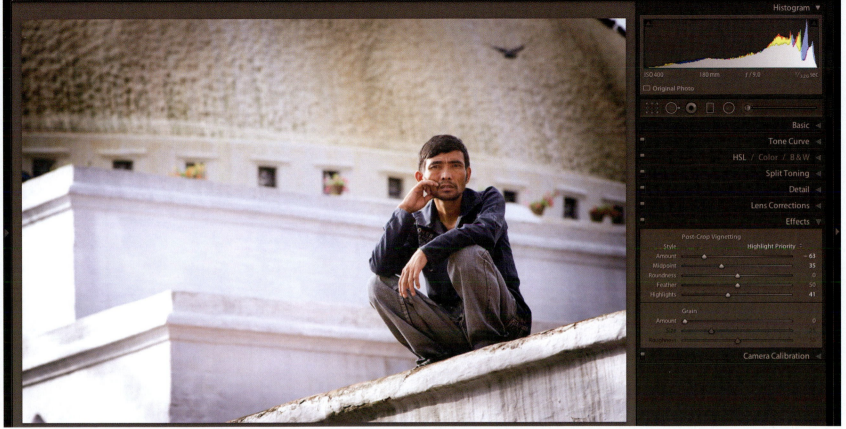

Explore the Highlight and Color Priority Vignetting styles in the Effects panel. Keep the vignette subtle so that it does not look immediately obvious that a vignette has been applied.

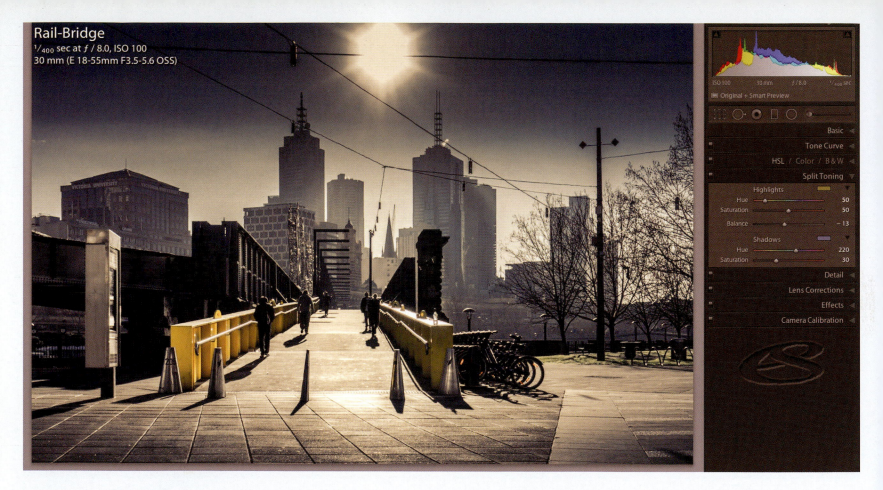

Rail-Bridge
1/400 sec at f / 8.0, ISO 100
30 mm (E 18-55mm F3.5-5.6 OSS)

Color Grading – Split Toning

Color grading can be applied to an image to provide a mood or 'signature style' to an image. This can be achieved by adding one color to the highlights and a different color to the shadows. This can be achieved using the Split Toning panel. Try experimenting with different color combinations.

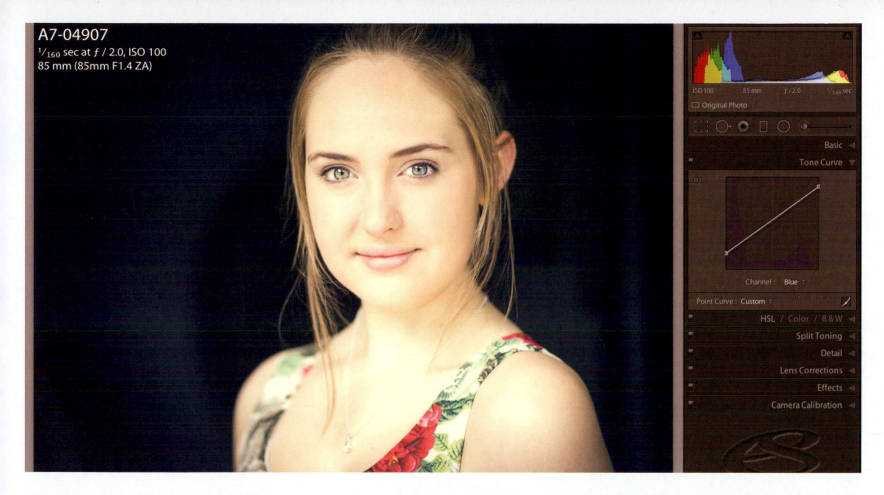

ISO 100 85 mm f / 2.0 1/160 sec

☐ Original Photo

Basic

Tone Curve

Channel : Blue

Point Curve : Custom

HSL / Color / B & W

Split Toning

Detail

Lens Corrections

Effects

Camera Calibration

Color Grading – Curves

An alternative to using the Split Toning panel is to use the controls in the Tone Curve panel. Switch from the Parametric Curve to the Point Curve and access the individual Red, Green and Blue channels. Grading in this panel can resemble faded film – blacks are weakened (made lighter) and highlights crushed (made darker).

Exporting Images

Save a Snapshot using the keyboard shortcut Ctrl + N (PC) or Command + N (Mac) before exporting your images. Use the Keyboard shortcut Ctrl + S (PC) or Command + S (Mac) to save the Metadata to the file. You are then ready to export compressed DNG files for Assessment. Go to File > Export and check the 'Rename To' option. Choose your family name, initial and the challenge number. In the File Settings choose DNG from the Image Format menu. Check the Use Lossy Compression checkbox. In Image Sizing check the 'Resize to Fit' checkbox, choose Megapixels and then enter 6.0 in the Megapixels field. Click on the Export button. You are now ready to upload your images for assessment.

Hard Drive

Export One File

▶ Export Location /Users/mark/Desktop

▼ File Naming

☑ Rename To: Custom Name

Custom Text: Galer-M-Challenge-1-01 Start Number:

Example: Galer-M-Challenge-1-01.dng Extensions: Lowercase

▶ Video

▼ File Settings

Image Format: DNG

Compatibility: Camera Raw 7.1 and later

JPEG Preview: Medium Size

☑ Embed Fast Load Data
☑ Use Lossy Compression
☐ Embed Original Raw File

▼ Image Sizing

☑ Resize to Fit: Megapixels ☐ Don't Enlarge

6.0 megapixels Resolution: 240 pixels per inch

▶ Output Sharpening Sharpening Off

▶ Metadata Normal

▶ Watermarking No watermark

▶ Post-Processing Do nothing

Cancel Export

Glossary

AF-C — Continuous auto-focus.

AF-S — Single auto-focus.

AI Servo — The camera continually focuses when the shutter release is half-depressed.

Ambient light — The available light without using flash.

APS-C — Sensor smaller than 35mm or full-frame.

Aperture — Size of opening in the lens that controls the intensity of light.

Aperture Priority — Auto exposure mode that prioritizes aperture over shutter speed.

Blinkies — Over-exposure warning on the camera's LCD screen.

Burn — To render a tone darker in post production image editing.

Camera Shake — Blur caused when the camera moves during the exposure.

Chromatic Aberration — Color fringing at the edges in the corners of an image captured with a wide-angle lens.

Clip or clipping — Loss of highlight or shadow detail.

Continuous AF — The camera continually focuses when the shutter release is half-depressed.

Cropped Sensor — Sensor smaller than 35mm or full-frame.

Depth of Field — Area of sharp focus.

Diffraction — An optical effect which limits the total resolution.

DNG — Digital Negative. Adobe's Raw file format.

Dodge — To render a tone lighter in post production image editing.

Drive Mode — A camera function that controls the number of images captured when the shutter release is depressed.

DSLR — Digital Single Lens Reflex Camera.

Exposure — The amount of light received by the sensor.

Exposure Compensation — A process of overriding the exposure selected.

Exposure Meter — A meter that determines how much light is required to establish an appropriate exposure.

Exposure Mode — This controls how exposure is achieved using the aperture and shutter speed settings.

EVF — Electronic ViewFinder.

F8 and be there — A photographic rule that guides a photographer to use average settings so that they can concentrate on capturing the moment rather than the camera settings.

F Stop — Numerical measurement of the size of the aperture.

Focus Area — The designated area where the camera will try to find focus.

Focus Mode — This controls how focus is achieved, e.g. Manual Focus, Continuous AF or Single Shot AF

Full Frame Sensor — A large sensor that measures 35mm across the width.

Full Frame Equivalent — The equivalent focal length when using a lens on a cropped sensor.

Golden Hour — The first or last hour of sunlight.

Histogram	A graphical representation of exposure values.	Prosumer camera	A camera that is of a standard between those aimed at consumers and professionals.
Infinity	The furthest point of focus.		
ILC	Interchangeable Lens Camera.	Raw	Image file that has not been processed by the camera.
ISO	International Standards Organization. A setting that increases or decreases the sensor's sensitivity to light.	Resolution	Optical sharpness of detail created by the number of pixels and the quality of the lens.
JPEG	An image file format where the image is processed in the camera.	Sensor	Light sensitive chip used to create a digital image.
Macro Lens	A lens that can focus at close range.	Shutter Priority	Auto exposure mode that prioritizes shutter speed over aperture.
Manual Focus	A setting that disables the camera's auto-focus system.	Shutter Speed	Duration of time used to expose the sensor to light.
Megapixel	One million pixels.		
Metadata	Image information about the camera settings used to record an image.	Single Shot AF	The camera focuses when the shutter release is half-depressed and then locks onto a subject.
Mirror-less Camera	A camera that has an electronic, rather than optical, view through the viewfinder.	Slow-Sync Flash	An image captured with flash where the camera's exposure settings allow the ambient light to contribute to the overall exposure.
Movement Blur	Loss of sharp focus due to subject or camera movement.		
ND Filter	Neutral Density or dark filter that reduces the amount of light reaching the sensor. This enables slower shutter speeds to be used.	Sunny 16 Rule	The level of illumination on a sunny day that does not require a meter reading in order to obtain an accurate exposure
Noise	A grain effect created by using high ISO settings.	Tv	Shutter priority.
Phase Detection Focus	An automated focus setting that can track movement.	Vantage Point	A position or place that provides a broad overall view of the location.
Post Production	Editing an image using software.	Zoom Lens	A lens that can change its focal length from wide-angle to telephoto.
Pre-focus	Set the focus prior to framing an image.		

Useful Links

http://www.cambridgeincolour.com

(theoretical principles explained)

http://www.markgaler.com

(author's website)

http://www.dpreview.com/glossary

(illustrated glossary)

INDEX